THE HUNT

Navigating the Worlds
of Art and Design

THE HUNT

Navigating the Worlds
of Art and Design

PATRICK PARRISH

powerHouse Books

Brooklyn, NY

Introduction

When my friend and the editor of this book, Wes Del Val, first asked me to write about what I've learned while working in the art and design worlds, I thought: *Why me? There are dozens of people more qualified.* That remained my response until I started mentioning the project to people, and they all said "You would be perfect for that!" So I started wondering why I *was* the right person to do it, and came up with some reasons that were compelling even to me.

To start, I've been at it a long time—like 30 years if you begin with my initial forays into collecting "modern" in college. I was always a collector, even as a little kid: rocks, coins, stamps, even spiders and snakes (I had 17 different species of snakes in my parents' garage and house at one point!), but my obsession with modern design started with a lightning bolt of an experience at the High Museum of Art in Atlanta, Georgia (the city where I was born), when I was a senior at Florida State University getting my BFA in Photography. The experience of walking up the long entrance ramp of Richard Meier's incredible postmodern edifice, to a building like I had never seen in person, or even in books, was thrilling.

Once inside, I found the exhibition "Machine Age in America" (which ran from December 1987 to February 1988). I hadn't gone to see the show, I went to see the building (which opened in 1983), and just stumbled upon it, and that certainly helped heighten the experience. I was literally gobsmacked by the streamlined industrial design that was produced in America from 1918–1941. I loved *everything* I saw, and in a very visceral way I connected with both the designs and the materials used. I immediately bought the catalog and poster and began trolling every antique, thrift, and junque shop and antique mall I could reach to find anything and everything that appeared in that book. I was obsessed! I vividly remember finding a Russell Wright "Sterling" ashtray in a thrift store in Tallahassee and freaking out. There it was, and he was a designer in the show! Since that find three decades ago, I have found dozens of pieces featured in that exhibition catalog, and dozens more which could be in it today.

Another reason I came to believe I am uniquely qualified to write this book is because I came into the design world from an interesting angle and at an interesting time. After FSU I entered the graduate program at the School of the Art Institute of Chicago, which was my first time living in a large metropolitan city where I actually had a chance of finding the type of modern design I was now seeking: small town Tallahassee was a little dry in that area, but at the time I did manage to find some nice things for my budget/experience. So, I was approaching design from an artist's perspective, and with several years already behind me seeking information about, and collecting, things that interested me. That background, combined with the timing of it being just pre-Internet, pre-eBay, and pre-1stdibs, and my being young enough to easily move through and adapt to all the upcoming, disruptive changes to the "antique world" (we didn't call it the "design world" then), made for some incredibly rewarding years gaining invaluable knowledge and growing my collection. I was unlike my older contemporaries and peers in Chicago. I remember the old-timers complaining about the Kovel guide books that came out back then: thick volumes with very few (terrible) black-and-white photos, but mostly just written descriptions of "collectibles"—price guides really. Those were somehow perceived as a threat, yet I embraced and pored over them and bought as many as I could afford.

The next disruption was by the auction houses. The dealers hated that there were starting to be stand-alone auctions of modern design. My friend Simon Andrews put together a seminal sale at Christie's London in 1984 which altered the landscape, and here in the U.S., the local Chicago auction houses started to follow suit soon after the New York houses joined the party. By 1996, both Christie's and Bonhams were doing design-only sales, and Sotheby's followed in 1997. I welcomed the changes and eagerly gobbled up every auction catalog I could get my hands on, new or old. Remember, this was all pre-Internet, so information was much harder to gather, but when you did find something it was a very powerful tool.

Next up, the Internet! This led to facts and figures being much, much easier to get and really made research into obscure design possible, and it was eBay which was *the* huge disruptor and true game-changer. I immediately embraced it as my older (though some not so) peers bitched and moaned and chose not to take part. After that came 1stdibs, which was universally hated by all the pickers and dealers in New York City, where I was now living, because of the access it gave dealers in smaller cities to sell to "our" clientele: the decorators, architects, and interior designers in the larger cities, especially NYC. I actually accepted 1stdibs reluctantly (I was getting up in years by then!), but did accept it. Same with Instagram. (But not Facebook, I boycotted that entirely!) I made fun of Instagram when it came out, and waited almost a year and a half before starting. If I had joined it when I was first shown by a friend, I truly believe I would now have hundreds of thousands of followers (not that it is the most important thing, but come on, there *is* significance placed upon it). You'll see several examples in this book of the effects of timing… I have been willing to regularly adapt to the changing playing field, and compromise where needed and when others wouldn't, and you know what? Many didn't survive.

So here I am in 2017, with a street-level, stand-alone gallery open to the public in New York City, in the great neighborhood of Tribeca. There aren't many of us left, (very, very few actually), and maybe I'm crazy—I could easily, and much, much, much more cheaply operate out of a warehouse in Red Hook, Brooklyn—but I want the street traffic. I want the public. I want to inform, to educate, and to turn people on to great design. And the only way I can effectively do that is to be accessible, available, and open with my gallery, my library, and the exhibitions I put on monthly. Stop in anytime!

Ray Johnson, Untitled (Bunny), USA, c. 1984

Can Money Buy Good Taste?

Absolutely: if you hire a decorator, interior designer, or architect with good taste! Otherwise, money is just a tool, and what you do with it depends on your skill level. There is so much out there that is super expensive and hideous, just as there are scores of things beautiful and cheap.

You will know rather quickly if you have an "eye" or not because if you don't, your friends or partner will likely let you know. If this is the case, enlist help, look, learn, and educate yourself by going to galleries, artist's studios, museums, fairs, and showrooms. By doing this, you can develop an eye, and begin to form and nurture your own personal style.

Gino Sarfatti, Table lamp, Model 594, Arteluce, Italy, c. 1962

Characteristics of Great Collectors

Passion
You need to really want it, feel it, live it, to be a great collector, otherwise you are just filling up your space with knick-knacks that won't mean anything to you in 20 years, let alone to anyone else.

Knowledge
Knowledge really is the key to success in any field, and with collecting, it is essential. Books, websites, blogs, Instagram, museums, libraries, studio visits, and hitting every single fair, flea market, antique store, gallery, junque shop, and even the dump (I'm not kidding!)—these are crucial to gaining the smarts that will give you the edge over all the other people looking for the same object.

Obsessiveness
Obsessiveness is useful if you are a collector, otherwise you miss the little details that "normal" people overlook. Being obsessive in real life can slow you down, but in the collector world it can give you a distinct advantage.

Drive/competitiveness or a Zen "I'll get what I get" attitude
I subscribe to both, but have found that being Zen and going with the flow, especially while shopping at large flea markets or antique fairs, can be very useful. If you see someone score something great right in front of you and then get upset and freak out (I've witnessed this reaction so many times), you lose your focus and create a mind-set where you are unable to "see" like you should.

An example: At the 26th St. flea market in New York City one Sunday morning, I saw a pristine pair of plywood Greta Jalk lounge chairs being carried into a booth. I quickly moved towards them only to have my biggest competitors literally step in front of me and ask for a price. The dealer told them $900 for the pair and my stomach dropped. They were easily $15–20K at auction, maybe more at that time. I stood there until they completed the deal (you never know, right?) and instead of losing my mind, which would have been a reasonable response, I made it a point to stay Zen, to remain focused, and keep working,

Originally executed by Lucio Fontana, Concetto Spaziale, Attesa, Italy, c. 1950

scanning the market. I turned and walked not 20 feet before I saw a dealer set out a shining golden box on his table.

"How much for the box?"

"40 bucks!"

"I'll take it," I said as I handed him the cash.

I sold that Line Vautrin box for $6K the next month, and while not $20K, if I had not remained cool, calm, and collected, I would have never been in the right head space to see it, let alone score it.

Curiosity

If you aren't curious, you really have no business collecting anything, right? Why would you? So yes, curiosity is a definite must for a collector, and the more curious you are, the more cool shit you will find!

Scholarship

This is important, but truth be told, a great eye can trump the book nerd approach a lot (but not all) of the time. I highly recommend the film *Who the @$#% is Jackson Pollock?* for a look into the world of connoisseurship versus scholarly, scientific evidence.

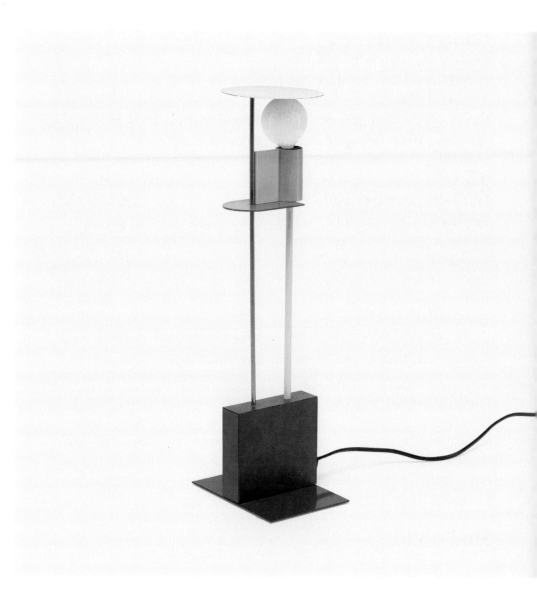

Gerard Taylor, Table lamp, Memphis, United Kingdom/Italy, 1982

Gallery Visits

Visit galleries often as the shows change every four–six weeks.

Always sign the guest book of those you like and leave your email address, so you'll know the upcoming schedule and get invited to the opening.

Galleries, especially here in New York City, can sometimes be a bit of a snooty affair, starting from the moment you walk in the door. If you can't see the gallerina's face, you are in trouble! The higher the reception desk and the less head you can see, the snootier it will be. But don't let that stop you! Remember that the people who work reception are the lowest on the gallery's totem pole. They probably make 1/4th of what you make at your job as they are notoriously underpaid, hence the attitude. I say this because I want you to take their posture with a grain of salt (and knowledge) and roll with it. Be super polite and nice, they likely won't care or show any reaction, but on the inside they will appreciate it.

Once past the gauntlet, look around, take pictures (always ask first, although these days no one usually cares unless it's a historical exhibition with works on loan), and take the show in. Curious about a price? Ask. They will tell you. They'll probably even give you a price list that you can walk around with (make sure to always return it). Grab the press release, they're usually in a stack on the desk and are a great source of info about the artist/s.

Studio Visits

Believe it or not, that amazing artist you saw on Instagram will more than likely agree to a studio visit if you ask. So ask! Studio visits are one of my very favorite things to do. They give you an insight into the artist's process, technique, and soul! Seriously, the studio is one of the most intimate places in the world, and to be invited in is truly a privilege. Artists (most) are dying to share what they feel so passionately about. So DM away, I swear you will not be disappointed! Once in the studio, here is what you do and don't do:

Andy Warhol, Self-portrait with camera (diptych), USA, c. 1973

DO

Be on time—they maybe won't be, but you need to be. Just because they sit around all day smearing paint on canvas doesn't mean they aren't very busy…

DON'T

Do not touch *anything* or take *any* photos without asking. And *NEVER* Instagram anything without permission. Taking a sneaky pic and posting it will get you banned not only by that artist, but by all of their friends.

Don't assume you can buy something from the artist at half price from their studio. Any ethical artist that is represented will either refer you to their gallery for a sale or split the sale with the gallerist. Anything else is really bad form.

Museum Visits

Do what I don't do often enough: see shows right when they open. I always wait until the very last moment, and inevitably miss some great shows. Going early is better, too, as there are usually fewer people, for if a show is great, with word of mouth and PR, they soon get packed. I went to the Picasso show at MoMA on the last day and it was a shitshow mob scene. I didn't even finish it. Never again.

Museum libraries are very underrated and well worth a visit if you have something specific you want to see. They may require registration, but some, like the Met's, are open to the public. They aren't for browsing, but if you go to the MoMA library and ask to see, say, all the Scott Burton ephemera, you will be amazed at what they will pull out for you.

Become a member. It beats paying the 20-40 bucks you would spend each time for yourself and a date. Plus, it goes to a good cause and gets you all sorts of perks.

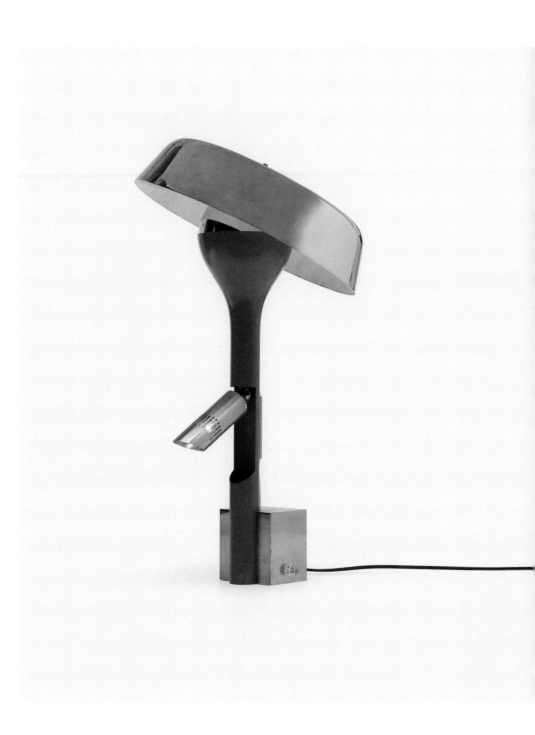

Angelo Lelii, Table lamp, Arredoluce, Italy, c. 1968

My Top 10 Museum Design Collections

Museum of Modern Art (MoMA), New York
Although I'm frightened by the rumors I hear about the department of Design and Architecture being absorbed and "distributed" throughout the other departments, they still are THE design museum...and their art collection ain't bad either.

The Metropolitan Museum of Art, New York
I'm not impressed with their new multimillion dollar logo or problems with the former director, but you can't beat the Met for their collections, and the Modern department's not too shabby—especially if you are into American Art Deco, which I certainly am!

Cooper Hewitt, Smithsonian National Design Museum, New York
Well, the Cooper Hewitt is "America's Design Museum," and it mostly lives up to that title with clever (sometimes too clever for my taste) shows and exhibitions. They also have the archive of Donald Deskey, one of my favorite American modernist designers.

Detroit Institute of the Arts, Detroit
They wouldn't get rich if they had to sell their collection of design, but they have a decent group of modern that is worth checking out.

Art Institute of Chicago, Chicago
My alma mater's museum, and a favorite place while I was living there. The "vintage" collection is nice, but the Architecture and Design department, curated by Zoe Ryan, is laser-focused and, in my opinion, has picked up where MoMA left off.

Los Angeles Contemporary Museum of Art (LACMA), Los Angeles
Wendy Kaplan's enthusiasm for modern design is contagious and she has

Frank Lloyd Wright, Rare executive office chair from Price Tower,
Bartlesville, Oklahoma, USA, 1956

done an amazing job. Her focus on West Coast designers is unique and it's always worth a visit.

High Museum of Art, Atlanta
For all the reasons I previously mentioned in the introduction, plus they've been aggressively expanding their contemporary collection and have, I believe, the world's largest collection of Joris Laarman. Well worth a trip to the Big Peach!

The Victoria and Albert Museum (V&A), London
The world's largest museum dedicated to decorative arts and design, which it's been showing since its opening in the mid-19th century. A recent personal favorite was "Plywood: Material of the Modern World."

Design Museum, London
This museum made a huge impression on me during my junior year abroad. I bought my first piece of "design" here, a cool rectangular flash-light by Nick Butler in plastic that had a flip-up lens/beam. MoMA later added it to their collection too, so I guess I picked right!

Bauhaus Archive Museum, Berlin
I've never been, but its online collection is amazing and a great resource even if you can't go there physically. I have seen pieces in their database that aren't in any of the Bauhaus books in my library.

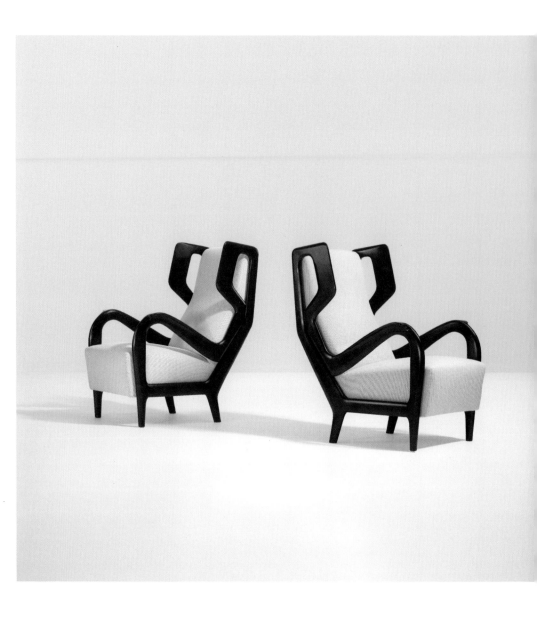

Gio Ponti, Rare lounge chairs, Aniberto Colombo, Italy, 1949

Art and Design Fairs

Art and design fairs are pretty similar when you dissect them, so I will talk about them together, differentiating when needed. While I'm not alone when I say I'm feeling a little burnt-out when it comes to fairs, they are still essential to our line of work and in some ways, the new business paradigm. If most fairs didn't require galleries to have a brick-and-mortar space, I think the fairs would have driven us all out of our ground-floor spaces. Most dealers do 3–6 fairs a year, with larger, blue-chip galleries doing 10–12 some years. This is a grueling schedule, and a model that is hard to keep up with. In the future I think the number of fairs dealers do will decline, but at this moment the pressure is still on, because new fairs are sprouting up like mushrooms.

Dealers participate in fairs for many reasons, but one of the biggest is to meet new collectors in different regions of the country or world. The second reason is the cash influx. While fairs are extremely expensive to do, they can also result in a very nice return as there is an urgency at fairs to buy, which is not often felt in the gallery space.

Why should collectors go to fairs? Many reasons: to learn, to feel the current pulse of the market, to hear the gossip, and to stay up-to-date. Oh yeah, and to buy things! While everyone scrambles to secure the hottest artists and designers on the first day, the best deals are to be had during the last half of the last day of the fair, especially at a design fair where the dealers would rather cut a sweet deal than re-pack and ship the piece back across the country or globe. This is called "bottom feeding," and as a dealer I've been more than willing over the years to cut sweet deals during the last few hours.

VIP Passes

Everyone talks about VIP passes, and what pass they have, and when they get in, blah, blah, blah, but actually, depending on your motives, the right VIP pass can make a *huge* difference in your fair experience. How? For some, it's to

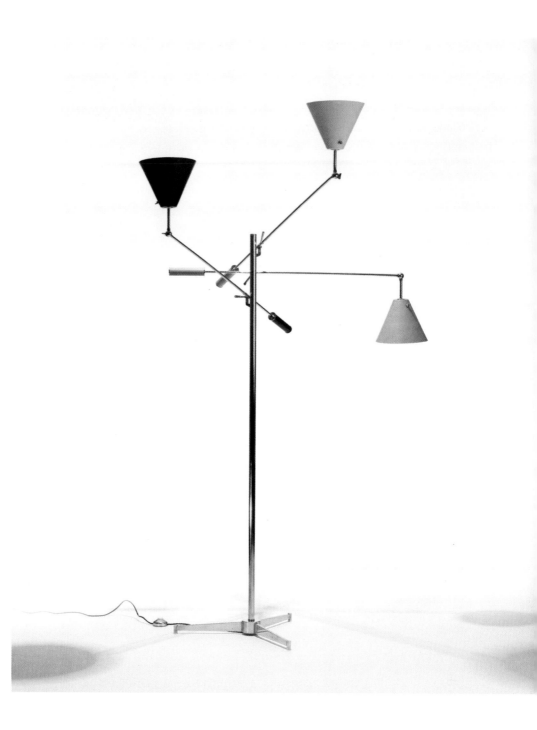

Arredoluce, Three-arm floor lamp, Italy, 1952

get a jump on their competition and snap up pieces early, before the crushing crowd comes rushing in. For others, it's to be seen getting in early, for net-working, and even for selling. For me, it's so I can actually *see* the pieces and actually *have* a conversation with the gallery, because at major fairs, once the vernissage (aka the shitshow party) starts, you can forget all that—it's party time and you'll get plenty of free alcohol, but you won't see anything in any meaningful way.

As one example, at Art Basel there are three levels of VIP that I know of, there could be more, (as Douglas Coupland said, "THERE'S ALWAYS A VIP CARD BETTER THAN YOURS"). One gets you in at 11:00 a.m. the day before the fair officially opens, the next is at 3:00 p.m., and the one after that is 6:00 p.m. for the vernissage. Even at 11:00 you'll have to wait in line because of all the new security after the X-Acto knife stabbing in 2015 (Google it), but once you're in it is a pleasure: clear aisles, clear booths, and serious people doing serious business. This is when you can see, enjoy, and learn about the art. If you're not buying, don't waste any dealer's valuable time during this moment; go back on Sunday when they are bored out of their minds.

How do you get on these VIP lists? Well, if you're a good customer of a gallery in the fair, ask them. If that doesn't work, ask around. If that doesn't work, you can try to register (for the next year, though) online. Shoot the fair's VIP program an email, explain why you should get in early, and if your reason is valid, *voila!* VIP passes will appear in the mail for the next fair. Probably not for 11:00 a.m., but beggars can't be choosers now, can they?

Gerhard Richter, Grun-Blau-Rot, Germany, 1993

My Favorite Fairs and Shows

Art Basel, Miami and Basel
The freak show of the art world. The debauched, excessive, winter party-fest in decadent Miami. Calling the circus that occurs around the main fair distracting or tacky or uncalled for is like saying New York City is loud and dirty—it doesn't matter, so just get into it! The Basel edition is much more subdued and serious, but still fun and well worth the crazy-expensive trip it can become.

Design Miami/, and Design Miami/ Basel
These fairs have events in both Miami and Basel, which can be confusing, so everyone calls the design fair "Design Miami," and the one in Basel "Basel Basel," to keep them straight. Same applies to the art fair. The original Design Miami/ is a "high concept" design fair. Before Design Miami/ there were just "antique shows" that might have modern in them, and regional modernism shows (New York's Modernism, which closed in 2005, being the lone exception) that were just gussied-up, flea-market-type experiences. The Design Miami/ franchise has changed all that, and promotes innovation and experiences. And the selected dealers deliver, upping the ante year by year. The fair in Basel, like its art world neighbor (and owner), is a bit more sophisticated and serious, while the Miami editions of both Art and Design deliver a crazy, fun, visual punch during the bleak, Northern Hemisphere winters experienced outside of tropical Miami.

The Armory Show, New York
This fair has had its ups and downs since debuting in 1994 in rooms in the Gramercy Park Hotel. You couldn't hang art on the walls (no nails!), so most dealers displayed their wares on the beds! The fair today is stronger, with new leadership, and I like it more now that they have mixed historical and contemporary together, instead of placing them on separate piers.

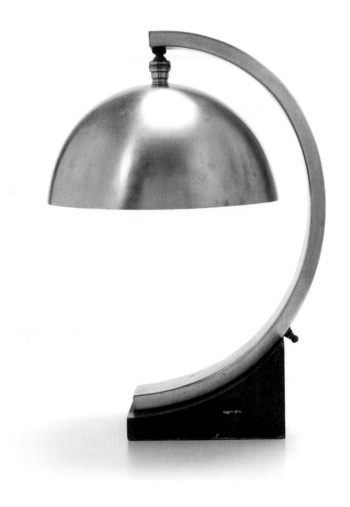

Donald Deskey, Table lamp, Deskey-Vollmer, Inc., USA, 1930

Collect, London
This beautiful fair takes place in the Saatchi Gallery in Chelsea and is the current leader in the promotion and selling of contemporary craft.

The Art Dealers Association of America (ADAA) Art Show, New York
I like the focus of this fair and the fact that most galleries present a single artist. Serious work and a serious crowd make for serious learning.

Frieze, London
The original Frieze has always done its own thing and tried to differentiate itself from all other art fairs, with limited and timed admission that controls the crowds and makes viewing the art easier as well as super-designed tents (rather than existing buildings) that are light-filled and roomy with quirky elements such as trees inside. I love everything about this fair and it is a pilgrimage I take to London every year.

Frieze Masters, London
The "grown-up" version of the original Frieze fair, this one includes exceptional examples of art from the Ancient era to the late 20th century.

Frieze, New York
This version is a great experience and I recommend taking the ferry to Randalls Island to get the full effect of the world's largest, free-standing structure (a tent), and all for art! The food is great, too, and it is one of my favorite events of the art year.

PAD Art + Design, London and Paris
I've never been to PAD Paris but the London fair is always worth going to—if not a little uneven. The first to mix art and design in a respectable way, I always look forward to a visit, but wish they would keep up with the times a bit and refresh their roster of dealers as the fair tends to look the same year to year.

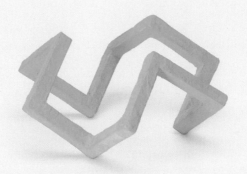

Josh Podoll, Untitled, USA, 2005

Zona Maco, Mexico City
I've never been, but hear it's great—and they have a design section as of a few years ago.

Collective Design, New York
Steven Learner's Collective Design fair is in its fifth year and has brought to New York a fair for contemporary design and art that was missing previously. It now has a competitor with the arrival of TEFAF.

The Salon Art + Design, New York
The Salon is in its sixth year and is a gem of a show, with a European feel and a nice mix of both art and design. Some of the top French Art Deco dealers like L'Arc en Seine and Vallois exhibit at this fair, and to see what they bring every year is well worth the price of admission.

FOG Design+Art, San Francisco
One of my very favorites to visit and exhibit at, FOG has no peer when it comes to mixing the worlds of art and design. There isn't another fair where a design dealer can exhibit right next to the likes of Larry Gagosian or Paula Cooper. Most shows—even where art and design are in the same building—segregate the design dealers to the side room, like a "kids' table" of sorts. This fair doesn't, and because of that, is unique in its perspective, look, and attitude.

TEFAF (The European Fine Art Fair), New York and Maastricht
I've never been to TEFAF in Maastricht, but the New York version is beautiful and chic, if a little fussy and fuddy-duddy for my taste (could have been the material). The spring edition was much more my speed with amazing contemporary and modern pieces being shown.

FIAC (Foire internationale d'art contemporain), Paris
FIAC is held in the Grand Palais des Champs-Élysées in Paris, which is the

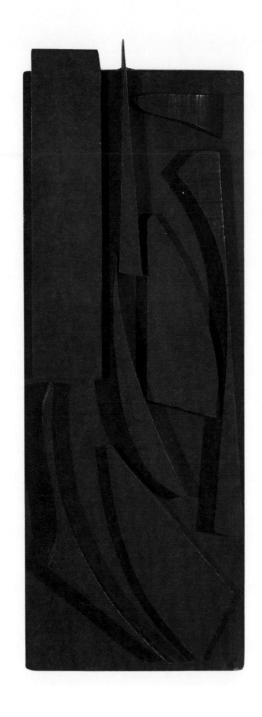

Louise Nevelson, Landscape, USA, 1957

most spectacular setting in the world for an art fair. The mood is festive in a French way, and the streaming natural light from the massive 1897 glass ceiling makes everything look good, including all the stylish Parisians who flock there.

NADA (New Art Dealers Alliance), New York and Miami
I like to call NADA the "cool kids" fair and it still is, kinda, but it's definitely growing up now that more established and older galleries are doing it. I like the Miami edition more than the NYC version, and it will be interesting to see what they do now that they are back at Ice Palace Film Studios, which is in downtown Miami instead of at the beach where they've been the last few years, before fire and a hurricane damaged their venue the quirky Deauville hotel.

LISTE Art Fair, Basel
This is my favorite satellite fair during Basel. It's the NADA of Europe and I love, love, love the old industrial building where it's held. Make sure to check out the bar at the top of the tower—it's well worth the 10-story walk up!

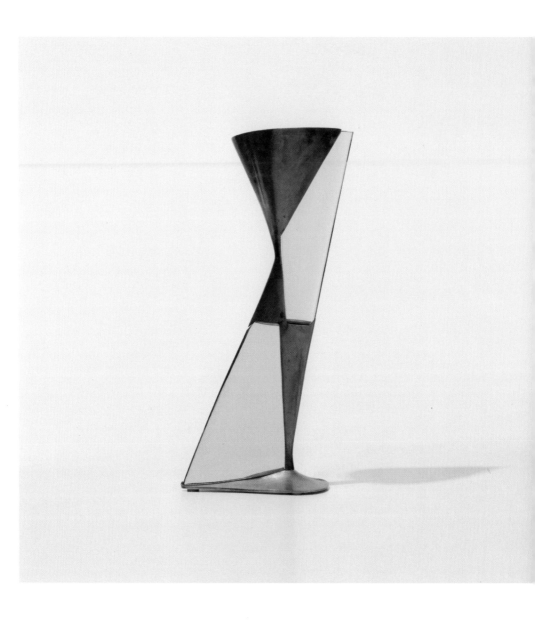

Max Ingrand, Table lamp, Fontana Arte, Italy, 1957

Starting a Collection #1:
What you like with what you have

Buy what catches your eye and buy the very, very, very best that you can afford.

When I started out, I thought 10 of something was better than one, but as I have matured and learned I now feel one of something, if it's "great," is much better than 10 things that are "good." For example, I used to collect cool Seiko watches because they were affordable and easy to get. But then I bought a Rolex in a pawn shop for the price of ten Seikos and I have enjoyed the Rolex much, much more. Everyone is different, but when it comes to collections I am of the "less is more" camp: quality over quantity. And as far as an investment, those ten Seikos aren't even close in value to the one Rolex now...though I do still have all of them.

Starting a Collection #2:
Overlooked objects and eras

Multiples, editions, and production pieces are a good place to start both with art and design. A production chair will always be cheaper than a limited edition or prototype, so when you're just starting, begin there. As far as overlooked pieces and names you can find right now, I would search for:

- **American Streamline Art Deco**: Donald Deskey, Gilbert Rohde, Wolfgang Hoffmann, Kem Weber, Walter Von Nessen
- **1960s-80s Italian pottery**: Raymor (distributor), Guido Gambone, Marcello Fantoni, Fausto Melotti, Ettore Sottsass, Bitossi (producer)
- **1970s American design**: Ward Bennett, Milo Baughman
- **1990s design**: Rei Kawakubo, Philippe Starck
- **Textiles**: <u>Always</u> underrated
- **Flatware**: Always deals out there
- **Chairs**: Easy to use and store, unlike a lot of other furniture
- **"Smalls"**: Can be the easiest to live with in little apartments

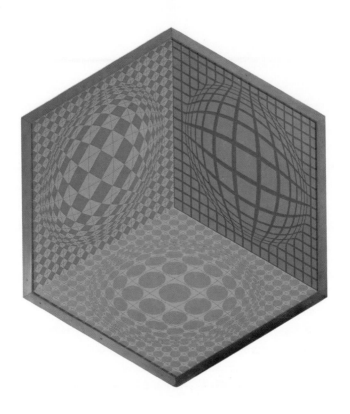

Victor Vasarely, Tri-Dagg, Hungary-France, 1979

Starting a Collection #3: Undervalued design

Most areas have come and gone, and experienced their ups and downs, and while some seem to die forever, such as Art Nouveau, others seem to come back perennially, like Memphis, which has reared its postmodern head every 8-10 years since the late '80's as the next great area to buy—with very limited success, I might add. If you are looking for bargains, go for:

- **Fiber arts:** These have traditionally been a hard sell, and hence an easy recommendation and buy. Extremely undervalued for many reasons: female artists primarily (blame society, not me!), condition issues, display problems, bad connotations and comparisons with trends like macramé, etc. I feel there is still a little time left to score big in this area, although the tide is rapidly changing. All you have to do is look at the prices of Sheila Hicks' amazing pieces to see the way it's potentially headed.
- **Arts & Crafts:** Once the darling of the design & art world (Robert Mapplethorpe and Jean-Michel Basquiat collected it), the A&C market is *dead* except for the very highest-end items. Extreme value here.
- **Industrial design:** Great industrial design from all countries is always undervalued and easy to find. Well, great stuff isn't *easy* to find, but it is out there and fun to look for because everyone had a toaster, but was it a great one? Maybe. So keep your eyes peeled at garage sales and especially flea markets.

 MoMA has a great collection of industrial design; it's actually what started their design department. The seminal show *Machine Art* fetishized ball bearings and stainless steel mixing bowls. The reprint of the catalog (with its steel-embossed cover!) is a must have, and easy to find on Amazon.

Achille and Pier Giacomo Castiglioni, Mezzadro stool, Zanotta, Italy, 1957

Underrated, overrated, trending, avoid*

- **All American "Hard Edge"/1950s design**: <u>UNDERRATED</u>. Because the equivalent French designs routinely sell for ten to a hundred times more. Look for: Allan Gould, Ward Bennett, Erwine & Estelle Laverne.
- **French mid-century design**: <u>OVERRATED</u>. See above! Jean Prouvé, Pierre Jeanneret, Alexandre Noll.
- **American Machine Age**: <u>UNDERRATED</u>. After a heyday in the 80s, these designs just might be due for a comeback with the recent show at the Cooper Hewitt, *The Jazz Age: American Style in the 1920s*. Gilbert Rohde, KEM Weber, Donald Deskey.
- **1970s design**: <u>UNDERRATED</u>. Especially 70s French design, a market that Suzanne Demisch and Stefan Danant have worked hard to expand at their gallery, Demisch Danant. As the obvious choices from the 30s–50s have dried up, the 70s are where to look next. The French ones to find: Janine Abraham & Dirk Jan Rol, Roger Tallon, Jean-Pierre Laporte.
- **1980s design**: <u>TRENDING</u>. The under-30 crowd finds it interesting as they have had no contact with it until now. They are geeking out on Ettore Sottsass, Rei Kawakubo, Nathalie du Pasquier, etc.
- **Hollywood Regency**: <u>AVOID</u>. It's a dubious look that has already passed and while slightly interesting in its purest original form, it is now sickly and too watered-down. Tony Duquette and William "Billy" Haines are the go-tos if you must.
- **American Craft**: <u>UNDERRATED</u>. You can find amazing handmade pieces of the highest quality for a fraction of the cost of something new: Phillip Lloyd Powell, Michael Coffey, Silas Seandel.

*Which means, of course, there will be people who think the exact opposite, some of whom will make a killing, others who will lose their shirts.

Roy McMakin, Rocking chair, Domestic Furniture Company, USA, 1988

Smartest Ways to Spend $1K/5K/10K/25K

$1K: Go to charity auctions; Artsy and Paddle8 run the best online ones. Not only can you get screaming deals, but your money will be going to a good cause, and might also be tax deductible.

$5K: Commission an unrepresented designer or artist you love to do something unique for you. $5K is just the right number to interest them and you will get a piece that will be singularly yours and worth twice what it would be worth if the designer was represented by a gallery.

$10K: Go to a dealer you *really* trust and say, "Hey, I've got 10K to spend, what do you recommend?" See what they say, and if you like it, do your research, ask for the best price, and make a deal! Cash is king and an immediate super-easy sale like this would really make the dealer happy, and if it is a vintage piece, I would expect you might get a 20-30% discount, maybe even more if the dealer isn't buried in it price-wise, giving you a $12-15K piece for around 10K.

$25K: Troll the regional auctions looking for something you like, things with estimates of $25-30K, because if you are on it and patient, something nice will slip through the cracks. Something does at *every* auction: the phone bidder can't be reached, two phone bidders can't be reached, the internet goes down for the auction house or for the other bidder, someone got the wrong lot number, etc. etc. So if you are watching, and have that amount to spend, I guarantee you will score something within 6–12 months of looking that will be worth twice the $25K you spend. It's what all of us dealers are looking to do at every auction, but we can't be everywhere all the time, and sometimes the auction gods just ain't with us. Also, remember: we won't spend $25K on something worth 30 or even $40K, as we need to double or triple our money on most deals, so if you are buying to keep, you have the advantage over us.

Christopher Dresser, Letter rack, Hukin & Heath, UK, c. 1878

Buying Without Seeing Pictures/Condition

Don't ever do it. Never. Even if it is from your very best picker friend who you have worked with for 20 years. The worst surprises and disappointments come from lack of communication, and visual communication is imperative in the visual arts. In this day and age, digital images are so easy to send and receive, anyone who is lacking or not willing to send images should be regarded with extreme caution.

Are there exceptions to this rule? No. So don't do it. If you feel you *have* to, get ready to pay the price...

Charlotte Perriand, Bibliothèque from the Maison du Mexique,
Ateliers Jean Prouvé and André Chetaille, France, 1952

Best Advice From the Many Interior Designers I've Dealt to Over the Years

Never, ever, be in a rush. That's when mistakes happen. I know you *must* have that stool in the mudroom *right now*, but take a deep breath (or several) and wait until you find the right one. Everyone says they are just going to get a "place holder" and upgrade when that right one comes along, but they *never* do, and it is these small, but important, visual details that really make the difference between a good interior (there are many), and a great one (there are few).

Decorate in this order: paint, select furniture, select lighting, select rugs, select art, select smalls.

Yes, flatware is important. It's like jewelry for the table. But it's also like a bad watch or bad shoes, it's the first thing people check out and if it's cheap and bad, you are starting off on the wrong foot. The good news is that cool, vintage flatware is relatively inexpensive, especially if you take your time to build a set. Some of my favorite designers made flatware, such as Arne Jacobsen, Gio Ponti, and Carl Auböck, so start looking. It's fun to track down.

If you are fortunate enough to work with a designer, trust them—that is why you hired them. If you feel your input is so important or better than theirs, hire another designer or do it yourself, otherwise you are wasting their time and your money.

Be adventurous! You can always repaint, replace, start over. Boring is just that, so go do something out of your comfort zone. You won't be disappointed.

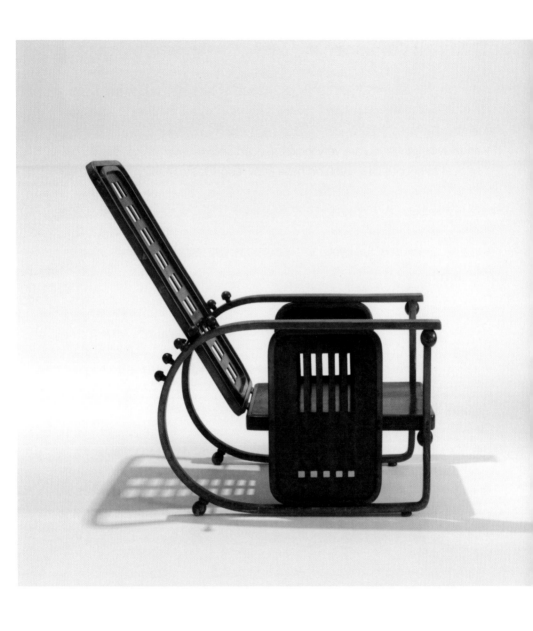

Josef Hoffmann, Sitzmaschine, Model 670, J. & J. Kohn, Austria, c. 1905

Using an Advisor

Depending on who you ask, art advisors are either seen as vital to the art world ecology or as cockroaches that have multiplied into an out-of-control swarm! I see it somewhere in-between. All major collectors use them, and they can be extremely helpful if you are very inexperienced and/or have no eye, but do have a budget to spend, OR, if you *do* have knowledge, taste, and/or a budget, but lack time. They can open certain doors (and also get some slammed in your face, depending on their reputation), and help you negotiate a better price (the difference of which will basically go back to them for their commission). They also know *way* more than you do if you are just starting out, so that's a big plus for a novice.

Advisors, like the entire art world, are not regulated in any way, so there is a *lot* of room for iffy behavior and shady deals. Double-dipping (getting a commission or kickback from the dealer *and* the client) is common, as is playing one collector client off another. This is especially bad in my book. All of these actions are unethical, and should be watched out for and avoided.

How do you decide on an advisor? By reputation and how well you get along with them, for you could potentially be spending a lot of time together at art fairs, gallery visits, sitting in an Uber, etc. So go with your gut, get references, and don't be afraid to ask lots of questions. There are advisors who are exclusively design-oriented, but they are fewer in number, so if you are interested in art *and* design, I would go with an art advisor, as they are getting increasingly more knowledgeable about design as their clients' interests expand.

Gertrude Abercrombie, Untitled (Still Life with Compote and Gloves), USA, c. 1950

Trusted Resources Who Have Never Let Me Down

Some of my very best resources for accurate and *free* information and buying advice are auction house specialists. Make friends with them, targeting the nerdy, bookworm geek, rather than the flashy, glad-handing big wheel (every auction house has both—one will always have time for you, the other won't). Once they get to know and trust you they'll not only give you advice and guidance on merchandise from their own sales, but also other houses' auctions, and even private sales. Remember, these guys and gals have literally SEEN IT ALL. So groom and grow those relationships and you won't be disappointed. People to seek out whom I totally trust:

Peter Jefferson at Wright
Peter is a walking encyclopedia of art and design. There is nothing he doesn't know or can't find out for you immediately. I never bid at auction without getting his green light first.

Simon Andrews at Christie's
This no-nonsense, design brainiac is an international specialist, meaning he oversees the design sales in New York, Paris, and London. When I say he has seen it all, I really mean it.

Brian Kish
You want to know something about Italian design, especially obscure Italian design from 1930–1970? Brian is the foremost expert in the world, in my opinion. He has solved mysteries for me that no one else could.

James Zemaitis
James is my American design guru, although his chops run deep in all areas as he was the head of design at Phillips and then at Sotheby's. Not a man of few words, James will talk your ear off, and if he does, you should take notes (or record it), as he knows the backstories of all great design objects and furniture. If there were a gossip columnist for the design world, he would be it!

Leon Polk Smith, Untitled, USA, 1969

Richard Wright

One of the smartest businessmen in our industry, Richard is who I call when I need financial advice regarding buying or selling design. His eponymous boutique auction house in Chicago is a great place to start collecting, as they have 28 (yes, 28!) auctions a year and there are deals to be had at each one.

Mark McDonald

Mark is the reason any of us design dealers are able to do what we do. He, along with his early partners Mark Isaacson and Ralph Cutler, were the pioneers of this business, starting in the 1970s. He is one of the most knowledgeable 20th-century dealers in the world, and museums and major collectors all over the globe count on him for advice.

Alex Gilbert

Full disclosure, Alex is my wife, but her experience in all aspects and corners of the design and art world make her an invaluable resource not only to me, but to everyone she knows in these fields. If she can't solve your problem, she knows someone who can.

Lily Kane

Lily knows everything about everything 20th-century, and that is not an exaggeration. If I need to know the obscure Hawaiian designer who worked in lava stone, she's the person I ask!

Christopher Wool, Untitled, USA, 1989

Buying From Established vs. Upstart Gallery

Should you buy from an established gallery or the new kid on the block? The answer is both, as they each have their upsides. The established gallery offers a provenance for you to use if you ever decide to resell, and they offer more services and will also have the staff to make the transaction smooth. The benefit of an upstart is the discovery of artists and designers that you didn't know of before. Plus new galleries will usually be cheaper, and perhaps friendlier, as well as eager to make a deal.

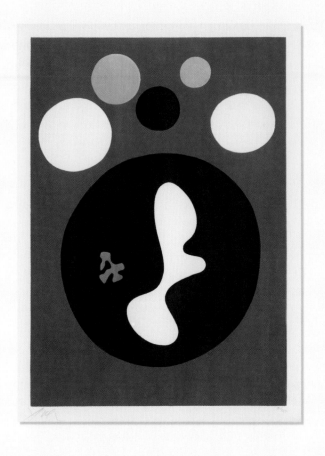

Jean (Hans) Arp, Gris-Noir, France-Germany, 1966

Etiquette in Galleries and with Dealers

First off, design dealers will, for the most part, be much easier to talk to than art dealers (sorry art dealers, but it's true), and you will probably even end up talking to the owner. If you went into the top design gallery in the world, which I believe is Patrick Seguin in Paris, and asked to talk to Patrick about a Prouvé cabinet, there is a very good chance you would get to. If you were to go into the top art gallery in the world, say Gagosian, there is not a snowball's chance in hell you would get to talk to Larry Gagosian in person, unless you were some sort of über-VIP.

I keep harping on this, but being polite and respectful in the gallerist's or dealer's space is crucial to a good rapport. Remember, they spend as much time there as they do at their home, and *are* in a sense at home there, so act like you are a guest in someone's house.

Talking on the phone as you walk around and look will automatically disqualify you from getting any respect at all (not to mention you won't really "see" the work), and you could easily be asked to get off the phone or even leave altogether.

Worth repeating in this day and age: It's always good to ask if it's cool to take pictures.

Don't be afraid to not know about something, as that will give the dealer a chance to tell you about it. Faking it will do you no good, and the dealer will know you are full of shit immediately and unfortunately, dismiss you as someone who is not very serious about what they, the dealer, are very passionate about.

Talking about price is fine, but wait until the very end of the conversation, maybe even the next day if you are really interested in buying. Believe it or not, the more you talk about something, and the more inquisitive you are, the better the chance you have of getting a nice price down the road. This is the opposite

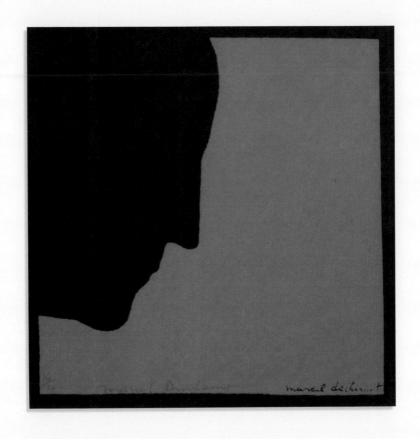

Marcel Duchamp, Self Portrait, France, 1957

of a flea market (more on this later), where you NEVER express any interest in something great, but instead comment casually about how nice it is, giving off the impression to the dealer that you could take it or leave it.

When price does come up, know that you can almost always get a 10% discount at the top art galleries and 15-20% at the top design galleries. If you are looking at contemporary design, 10% is usually the max, while secondary-market vintage or contemporary it's 15-20%. Lower level galleries and antique shops are more likely to discount more deeply, but I would never expect any more than 25-30%. More than that, and you should wonder why they are so desperate to get rid of it!

Things never to say to a gallerist

Very important, <u>avoid</u> saying:

- **"I'll give you..."** That style of negotiating may go over in a souk or Middle Eastern market, but nowhere else, so don't even try it.
- **"This is: damaged, dirty, ugly, broken, common, overrated, over-priced, etc. etc. etc."** When you actually want the piece, insulting or demeaning it will never, ever, ever, ever work, yet I hear it all the time when I'm at a lower-level antique show or flea market. It is an amateur move, and one that will get you nowhere fast. There are dealers who are known to do this, and they are universally hated, ignored, and avoided by everyone else.
- **Asking for a discount of more than 20% in the design world and 10% in the art world** is risky unless you are very friendly with the dealer. Asking for 30%-50% off, unless offering something else in return, like a trade or cash, might get you asked to leave the gallery or shop.

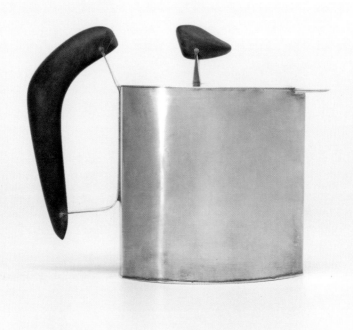

Harry Bertoia, Important early teapot, USA, c. 1942

Garnering preferred treatment

Do a little homework and go prepared to discuss what they are showing.

Ask questions, be curious.

Ask to be put on the mailing list.

Take a card and follow up with a thank you or more questions.

Go regularly to the openings, and make friends with the employees and directors.

How to make dealers like you, even if you spend no money

I can't stress this enough: be curious and show up to all of their openings!

Write about the artist/designer's work on Instagram, or blog it (if you are an old-timer). Just because you don't spend money doesn't mean you can't be a valuable asset/customer/fan of the gallery. Sometimes spending $1,000 bucks on a piece of pottery versus simply Instagramming that piece of pottery can ultimately carry equal weight, influence-wise, and smart gallerists know that, and will make it worth your while when you do have the money to spend on something. If this business was solely about money, we would all be hedge fund managers or brain surgeons instead.

Good questions to ask when you are interested in something but know nothing about it

What is this amazing piece?

When was it made?

How does it relate to _____ (someone you do know about)?

Where did they go to school?

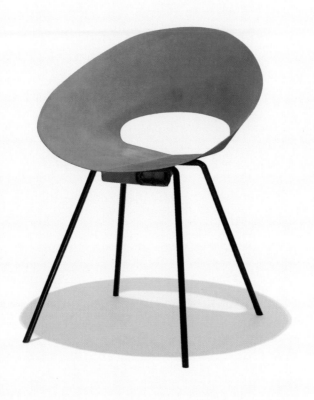

Donald Knorr, Chair, Model 132 U, Knoll Associates, USA, 1948

Who are their contemporaries?

Are they still alive?

Do they have an auction record?

What else can you tell me about them?

<u>Negotiating prices</u>

Ask nicely for the best price. *Never* say "I'll give you..." which is so important to remember that it's worth mentioning again so soon. If you can't tell, this really is a major turn off and pet peeve of mine.

Feel free to offer a little less than what they say is their best price, but no more than 5-10% unless you have a very friendly rapport with the dealer and/or are a friend. Don't be afraid to ask for terms (time to pay/payment plan) but know the discount will be less.

Don't play games or string anyone along. It's OK to say that it is too much for your current budget, or that you changed your mind, but the sooner you do that the better.

Don't put anything on hold for more than 48 hours.

Feel free to ask to take the piece "out on approval." How that works is that you give the gallery a credit card, and they arrange for shipping, which you pay for, to your place. If it looks great, you keep it and pay for it immediately. If it doesn't work, you return it to the gallery at your expense. This is more common with design galleries but art galleries also do it. If the piece you are interested in is part of a show, you will obviously have to wait until the show is over.

Warren McArthur, Early armchair, Model 20, Warren McArthur Furniture, USA, c. 1931

Payment

CASH IS KING.

The faster you pay, the more the gallery will like you. The longer you take, the more you will annoy them.

A check is *not* cash, but better than a credit card. If you pay with a credit card, remember that the gallery is paying between 2-5% to process that card, and that could affect the discount they give you.

Insurance, rules of thumb

If you have the resources, *always* insure everything for *replacement* value. If not, and there is a problem, you will get only 30-50% of its true value, maybe even less.

If you're buying from an auction house, some credit cards, such as American Express, will cover your purchases and give you more leverage if something goes wrong, is damaged, or is misrepresented—but always read the fine print at each house before you bid.

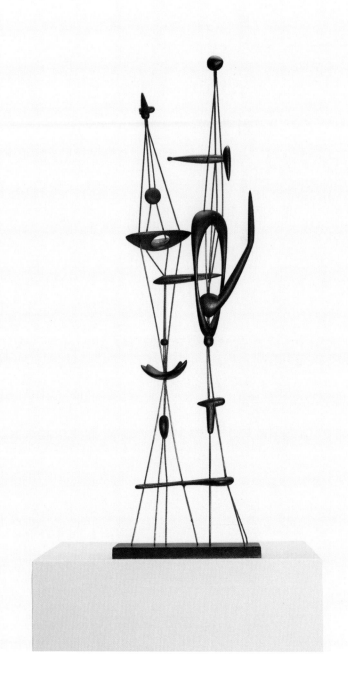

Leo Amino, Untitled, USA, 1954

Selling vs. Holding

If you're in this to make money, there are better and more stable places to put it, like a mutual fund. But I would be lying if I said I didn't routinely think about the impact of what I buy on my collection's present and potential value—but then again, I *am* a dealer.

If you are a true collector, really true, you never sell. (Check out the documentary *Herb & Dorothy,* which will show you what "true collectors" are, in the purest sense.) That being said, good and even great collectors sometimes have to sell things to upgrade their collection and finance those purchases. So, whether to sell or hold depends on the piece and how the market is doing. The art world is MUCH more volatile than the design world, like by a factor of 10, but both require you to really, really pay attention to the auction market, what is selling at all the fairs, and what the dealer gossip is.

I know firsthand that dealers in design can't keep their mouths shut, so ask questions, especially at openings where the cheap wine or beer is flowing—you'll be surprised at the information you get!

Jeff Koons, Bread with Egg, USA, 1995

Trading with Dealers

Dealers *LOVE* to trade. Why? Because it's "free," no cash is exchanged, and they get something that is new and fresh to them and maybe even to the whole market (which is the *best* scenario). So if you have something to trade, don't hesitate to offer it up as a possibility, as it can be a great way for a collector to upgrade without, again, laying out any money.

Don't be concerned with getting the last dime in a trade; they're never perfectly equal monetarily, but become equal when both parties are happy and get what they want, which is a win-win situation!

Ed Paschke, Bella Donna, USA, 1979

Contacting Artists Directly vs. Through Their Gallery

OK, we are on dangerous ground here as everyone wants a deal, but to go directly to a represented artist (one who has a gallery, or galleries they work with) and try to cut out their gallery is a big no-no for so many reasons. If you become friendly with a gallerist, they will eventually put you in direct contact with the artist for a studio visit (I touched upon this previously), but all sales should go through the gallery. I'm naturally biased here, but the artist/gallery relationship is a symbiotic one, and to keep it healthy and stable this needs to be how sales happen.

If an artist is unrepresented, or has no formal contract with a gallery, then totally go for it. But know that buying from artists can be tricky as they can be weird about money and sales, but if they aren't, you can have a lot of fun and get great stuff. Plus, you get to go to their studio, and as I mentioned earlier, artists' studios are amazing places to be and hang out. You will always learn something. And don't forget to bring a six-pack of beer as a studio warming gift!

Richard Artschwager, Book, USA, 1987

Appreciation vs. Depreciation

We all want things to appreciate and gain value, but it's actually very rare, unless you are buying below market to begin with. So, don't be overly concerned about it, rather, buy what you love and can use, and let your grandkids worry about it.

Good design and art always "appreciates" in some way—the artist gets more well-known, the work gets in shows and into the consciousness of people—but that type of appreciation doesn't always keep up with inflation, so if you sell something, you *might* get your money back.

I'd make the point here about buying furniture that will at least *retain* its value. Buying vintage furniture vs. IKEA/West Elm/CB2/etc. will ensure this. An accurate analogy would be comparing it to driving a new car off the lot—the moment you walk out with the IKEA credenza or whatever, its value plummets.

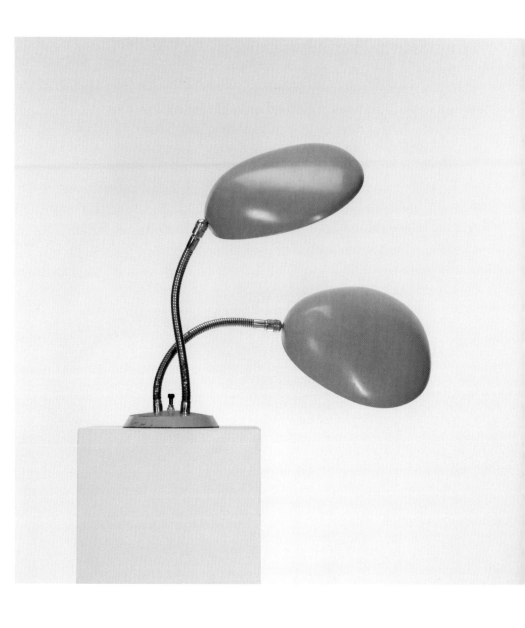

Greta Magnusson Grossman, Double Cobra table lamp, Ralph O. Smith,
Sweden/USA, c. 1950

Timeless vs. Trendy

All "timeless" design was trendy at some point. People forget that the classics of today were very radical in their time. What seems like an easy and safe choice now was usually a real risk, taste-wise, back when they were first shown, like the Barcelona Chair, Eames plywood chairs, and anything by Marcel Breuer.

When considering collecting contemporary design or art, I recommend buying what seems difficult to you. Don't get me wrong, you need to like it, but if it makes you or your partner seem a little uncomfortable for whatever reason, whether its form, material, color, construction, subject matter, etc., and if your friends don't get it, you are probably on the right track.

Man Ray, Chess set, USA, 1920

Blue Chip Investments

There are certain artists and designers that never seem to go down in value; but for every Pablo Picasso or Andy Warhol, there is a Sandro Chia or Francesco Clemente. The old adage, "Buy what you like," is always a good one, but come on, everyone wants to hear or know that the piece they bought for $1,000 is now worth $10,000—if not for themselves, then for their kids (or ex-wife…not!). So, what artists in design have that Warhol/Picasso magic? Here are my picks (in no particular order):

- **George Nakashima**: The godfather of organic design.
- **Gio Ponti**: The greatest influencer in 20th-century Italian design, he also had a worldwide reach as the editor of *Domus* from 1928–1979.
- **Émile-Jacques Ruhlmann**: Although not as fashionable as he once was, the quality and craftsmanship still shine through, and his prices are always astronomical.
- **Jean Prouvé**: Almost cliché these days, if he wasn't so fucking good—especially his structures.
- **Charlotte Perriand**: The pieces by her that were once claimed to be Jean Prouvé are now rightly attributed, and it only took a court of law to do it!
- **Eileen Gray**: Le Corbusier would have not had the influence he had with his furniture designs without her. His vandalization of her only building, E-1027, shows how much he was intimidated by her designs.
- **Carlo Scarpa**: Known in some circles only for his glass designs and the crazy prices they bring (which can top $250K for a single bowl!), he was first and foremost an architect, and one of the greatest.
- **Carlo Mollino**: He was a photographer, expert skier, pilot, and race car driver (even racing at the 24 Hours of Le Mans in a car he designed). How he also had time to design amazing furniture

Enrico Castellani, Superficie bianca, Italy, 1965

and interiors, I will never understand.

- **Wendell Castle**: Not universally loved, but extremely talented, and what staying power! He's still at it today at age 84. And stylish? Always.

- **Ron Arad**: Same as Wendell, universally loved-wise, but he has had quite an influence on the current crop of young designers.

- **Marc Newson**: Marc designs spaceships and stainless steel surfboards, and is the only designer to be represented by Larry Gagosian, so need I say more? Love him or hate him, he is the Picasso of the design world.

- **Ettore Sottsass**: I don't think anyone has had more influence on young designers and their tastes over the last decade than Ettore and his Memphis Group. I've seen his stock rise and fall over the years, but never soar to this extent.

- **Isamu Noguchi**: A sculptor who had great influence in the decorative arts with his Akari Light Sculptures and furniture for Herman Miller and Knoll. Isamu's work encompasses some of the finest examples ever of 20th-century design. In 2016 his table for A. Conger Goodyear's house sold for $4.45 million at auction!

- **Gerrit Rietveld**: The Dutch Master is one of my favorites and the most prolific chair designer that I know of—all of them amazing, and all worth five figures at least.

- **Alexandre Noll**: Although his market has been greatly affected by fakes, his best work is both beautiful and functional.

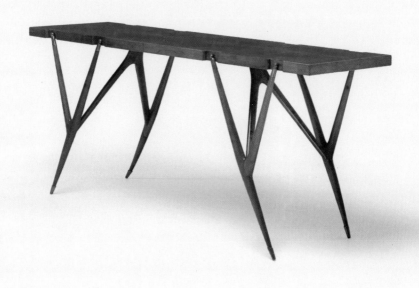

Ico and Luisa Parisi, Console, Singer & Sons, Italy, c. 1952

My Design Heroes

Enzo Mari

I've heard that Enzo is a crabby old fuck (yes, he is still alive), and I would love just one time to be on the receiving end of that legendary temper and outspokenness. The way his brain works, the width and breadth of his designs, are only equalled (and I might even argue surpassed) by Bruno Munari (whom I gush over next). Living designers? He has no equal, and because he has a love of paperweights like I do, he will always be one of my idols and favorites.

Bruno Munari

The true genius of 20th-century design, the Leonardo da Vinci of the design world, yet most people have no idea who he is. Why? Why do fish jump? You will get a lot of answers, but none will be right and none matter. What does matter is that if you don't know who Bruno Munari is, find out. A true polymath and genius, he executed designs in a fun, smart, and visually beautiful way every time.

Charlotte Perriand

On my blog *Mondoblogo* (almost never updated anymore, though all still online waiting to be read by anyone, anytime—seriously there's loads of great art and design-related stuff to see and read on there), I described Charlotte as "cute as a bug and smart as a whip." She was living in a man's world in Paris and out-designing them, but not getting the credit she deserved, until very recently. A collaborator of Le Corbusier, while work-ing with him she designed some of the most seminal designs of the 20th century.

Eileen Gray

On the blog I also described Eileen as ahead of her era, and boy, was she.

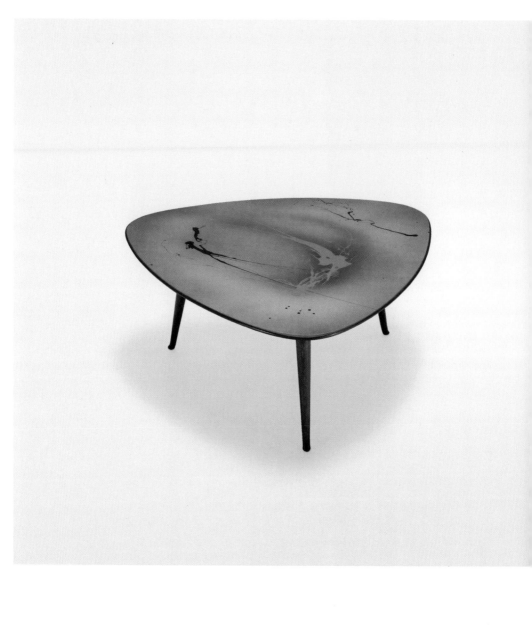

Osvaldo Borsani and Lucie Fontana, Important coffee table, Italy, 1952

Some of her designs from the 1920s look like something from another time and place. She led a fascinating life and was another victim of Le Corbusier. (He really was a nasty genius, wasn't he?) It's worth tracking down the film *The Price of Desire* to get the dramatized 1938 story of Eileen, Le Corbusier, and her villa, E-1027. This film and other written accounts will give you doubts about our "hero," Corb, and leave you with a better understanding of what a genius Eileen Gray really was.

Theodore Waddell
Theodore Waddell is the most underrated lighting designer of the 20th century, in my not-so-humble opinion. Some would say it's Gino Sarfatti, but I will argue them under the table. Despite having two designs in MoMA's permanent collection, no one knows who Waddell is. He's not a bad furniture designer either!

Ruth Asawa
Ruth Asawa is an amazing artist who was thought until recently by most to be just a "craftsperson," which she certainly was, but she transformed wire into three-dimensional, non-functional sculptures and is only now getting the full recognition she deserves, with her auction prices shooting through the roof. To give you an idea, you used to see her work in antique stores (at least I did, on more than three occasions), and now her estate is represented by David Zwirner. Like most greats, especially women, she never lived to see her day.

Buckminster Fuller
America's equivalent mind to Bruno Munari. More of an engineer's brain than an artist's, but still an artist through and through. His contributions to society are still playing out, and his lust for knowledge and painstaking documentation of every day of his life, with his *Dymaxion Chronofile* (Google it!), is an inspiration to me and should be to you, too.

Paul Evans, Wall-mounted sculptured metal cabinet, Model PE 40,
Paul Evans Studio for Directional, USA, 1969

Greta Magnusson Grossman

To understand Greta's place in the pantheon of 20th-century designers, you have to look at old trade publications such as *Esempi* (from Italy), where Greta would have full-page spreads of her designs, and Charles Eames (there was no mention of his co-designer and wife, Ray) would have a 1/4 page. She is more well-known now thanks to the hard work of dealers and historians, and because of the reissue of some of her designs—but she still isn't the recognized name she should be.

Carlo Mollino

The true superfreak of 20th-century design, Carlo would sleep for weeks straight and then work maniacally for months at a time with no breaks. Carlo holds second place for the highest price ever paid for a 20th-century design object (behind Eileen Gray), and also holds a place in my heart as my very favorite designer.

Leza McVey

A little-known but brilliant ceramicist who studied under Maija Grotell at Cranbrook. Her quirky and idiosyncratic zoomorphic forms are little known to those outside the ceramic and museum curator worlds. Check her out.

Maija Grotell

The grand dame of modernist ceramics and a great teacher who has influenced many great ceramicists. Although she is also not as well-known as she should be, her influence lives on to this day.

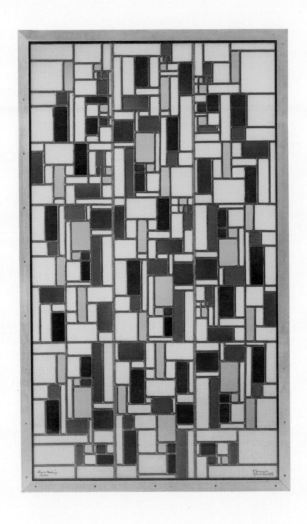

Theo van Doesburg, Important stained glass window (Composition V), Bogtman
Haarlem, The Netherlands, 1917-1918

Art vs. Craft

I find very little difference between works of art and craft. I mean, I'm not usually calling a macramé wall hanging a piece of art, but it definitely could be. Up to the early 2000s, the word "craft" was almost a dirty word to some. Look at the ridiculous renaming of The American Craft Museum to MAD (Museum of Arts and Design) in 2002.

Luckily, we are in a period where craft is respected and revered again and not relegated to the suburban shopping mall craft fair. There is lots of bad craft, just as there is terrible art. In fact, I would say that most art and craft is bad—really bad actually. (Of course if it is really, really, really bad, it can be good!) But when it is good, I really see no difference.

I routinely call my designers artists because I think they are. Is a painter a craftsman? Maybe. Depends on how and why she paints. Is a basket weaver an artist? Possibly, especially if they see themselves as one, or if their skill level is such to elevate something so utilitarian to a higher realm. A lot of designers I work with incorporate self-expression into their designs, making them all artists in my eyes.

Alexander Calder, Light fixture for Léonie and Geddes Parsons, USA, c. 1960

Buying at Physical Auction

ALWAYS preview the auction yourself, and I mean in person, not online. If you can't, you *must* ask for a condition report, and if you really want to cover yourself, ask for one of the house specialists to go over the piece on the phone with you and to send detailed photos afterwards. The specialists are just that, so use them and take advantage of their knowledge even if you aren't a serious buyer, because one day you might be, and if they are smart they know that.

At an auction preview you are welcome to handle the pieces and you should. Even at Christie's and Sotheby's you can touch, turn over, open up, and take pictures of anything there. It's always polite to ask first, and that is good form and preferred, but you have every right to inspect to your heart's content something you might be bidding on.

Make sure you register to bid. Some auctioneers will recognize an un-paddled/numbered bidder, but others won't, so don't take that risk.

A smart bidder stands in the very back, against the wall, so no one can see them bidding unless they physically turn around, craning their necks and giving you, the bidder, time to lower your hand.

There are different tactics to psych-out a bidder, such as jumping the bid (going up several increments at once, say from 100 to 500), but my favorite is just to hold your paddle up and don't take it down. With this method, you want people to see what you are doing. If your competition is on the phone, this obviously won't work to your advantage, but if they are on the floor, I have found it highly effective (and sometimes slightly intimidating) if it's something I must have and feel the room doesn't know its value.

Remember: at most auctions you will be paying a 25% buyer's premium, so something that hammers at $1000 will cost you $1250.

Richard Pettibone, Up M1002 and Hiraqla #3, USA, 1970

Buying Online

eBay is still *the* flea market of the 21st century. Other sites like Etsy and even Instagram have chinked its vintage armour, but it's still my go-to to find stuff cheap, fast, and easy, from the comfort of my home/bed/desk/beach chair.

Bad eBay photos, coupled with a seller with good feedback = a potential score. Don't be afraid of shitty photos, they are your best friend. Bad feedback on the other hand = a bad experience. Avoid at all costs no matter how tempting it may be.

Want sellers on eBay or any other site to like you? Pay fast—I mean immediately after the auction ends.

Leave complimentary feedback once you have received the item, *never* before.

Always ask questions. If you don't get answers, beware.

Everyone asks sellers to end auctions early. So should you. Ask nicely for them to set the B.I.N. (Buy It Now) price, and if they want you to make an offer, make a fair one.

Don't play games, and if someone is playing them with you, don't engage, ignore.

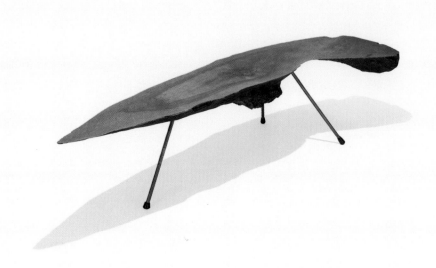

Carl Auböck II, Table, Austria, 1950

Provenance/Authenticity

Should you worry about this? Yes. If you are buying from a top dealer or auction house you can assume that the P/A is pretty tight, but you know what happens when you "assume"…

P/A is very important when buying from a dealer or at auction. Just buying something at auction does not guarantee it is authentic, but the higher up the food chain you go, from Rago to Wright to Phillips to Sotheby's and Christie's, you can generally rest assured—regardless, it helps if you get the provenance, or guarantee that it is authentic, *before* you bid, not after. Read the "fine print" in the back of the catalog, but not too carefully or you will never buy anything at auction again (it typically goes on for pages in "legalese" and favors the auction house *greatly*).

If you are buying from a reputable dealer, your invoice (make sure it has a photo) will act as provenance for contemporary works 100% of the time. It's great to have for vintage pieces as well, but to be sure, you would need it confirmed by an outside source or appraiser.

Certificates of authenticity (COA)? It's tricky. Unless they're from the artist's estate, or the gallery that represents the estate, I get scared when I hear those words from someone trying to "prove" via a piece of paper that their piece is real. What's the easiest thing in the world to fake? A certificate of authenticity.

Always remember to ask the dealer, auction specialist, even the vendor at the flea market, for any and all information they have on the piece. Very often a flea market dealer might forget to give you the paperwork they received at the estate sale. Auction houses and dealers will be glad to provide it, all you have to do is ask. You can skip asking the lady at the thrift shop, but then again you never know, she may go, "Oh yeah, here is a folder of papers that came with that sculpture." Forever be prepared to be surprised in the hunt…

Philip Johnson and Richard Kelly, Floor lamps, Edison Price, Inc., USA, 1953

Originals vs. Reproductions

Always buy a vintage original when you can. If that isn't possible, a licensed version is ok, but never, ever, ever buy a knock-off or fake version of any design. They are not only worthless in the long run, but buying them supports the knock-off artists that are the bane of the furniture and design industries.

Try not to buy, "In the style of..." meaning watered-down versions of a great or classic design. The Mulhauser version of the classic Eames lounge chair is a good example of this, and something I try to avoid at all costs.

Investigating furniture to see if original, reproduction, or fake

The finish on a piece is your first clue. If it is original and untouched, with normal wear, that's a great sign. If it has been refinished or reupholstered, that's the first clue something could potentially be wrong. Turn the piece over (bring a flashlight), are there labels or markings? Both good. Does it look "messed with," or are there extra holes by the legs, or shadow marks of some other base?

If it looks too good to be true, it almost always is.

Look for signs of wear, if it's in places where it shouldn't be, then that is a very bad sign. Wear should be reflective of use, natural and normal-looking, and can add to a patina which can substantially contribute to the value if it is mellow, normal, and beautiful to look at. The best pieces have a glow, because they have been well-used, respected, and looked after by their loving owners.

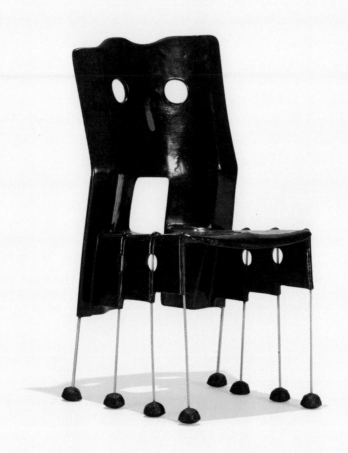

Gaetano Pesce, Greene Street chair, Vitra, Italy/Germany, 1984

Repairing Objects

If the cost of repairing something is more than the value of the object, you should really consider leaving it as is. Actually, I frown on repairs unless they're an absolute must.

Same goes for refinishing and restoring pieces. 90% lose their vibe when they get stripped and redone. If you think about it, to refinish something you are literally stripping it of its skin. Not a cool thing to do, right? So bypass it at all costs.

What can and can't be repaired

Glass can almost never be repaired, so avoid damaged glass.

Ceramics are pretty easy to repair, so that is a good method for getting something great—look for pieces that everyone else is passing over because of damage. Chips and clean breaks are much, much easier to repair than cracks, so skip pieces with cracks, especially "hairline" cracks.

Wood and metal is pretty easy to restore, as is stone, believe it or not. Plastic's nearly impossible, so avoid any damage.

The truth is, anything can be professionally restored, it's just gonna cost you dearly when you get into the more difficult materials. If something is of sentimental value, by all means restore it even if it costs more than it is worth, but if not, donate, sell, give away, and move on to the next piece.

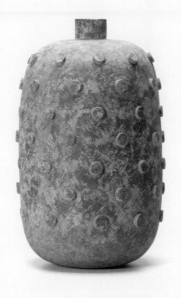

Claude Conover, Buul vessel, USA, c. 1965

Insider Terms

- **26th Street**: Flea Market in Chelsea, New York City.
- **All the money**: Either paying or getting the very top amount for something. Can be a good or bad term, depending on what end of the deal you are on.
- **Big Brimmer/Brimmer**: Brimfield Antique Market in Massachusetts.
- **Bottom-feeding**: Extreme bargaining at the end of the fair or market: frowned upon, and only has a chance of working at the very last hours of the last day, and even then it is risky.
- **The Bowl**: Rose Bowl flea market in Pasadena, California.
- **Box lots**: Cardboard boxes at an auction that are filled with stuff, 99% of the time it is terrible worthless junque, and a waste of looking—but you are not supposed to leave any stone unturned, right?
- **Brain-pick**: Asking another dealer for information on an item. If they want to buy it from you, giving you that info could drive up the price for them. You can ask for a brain-pick one to three times a year, depending on who you are asking. More than that, and you'll get a bad reputation for being a "brain-picker."
- **Buried in it**: Having spent more on a piece than it's worth once you have restored it.
- **Burned**: Something that has gone unsold at auction one too many times.
- **Cherry**: Mint condition.
- **Condo-modern**: cheap 70s and 80s furniture that looks cool, but is shit, construction and material-wise.
- **Deadstock, New Old Stock**: Unused vintage item.
- **Dreck**: Bad merchandise.
- **Early buyer**: To be successful this must be you at any flea market.
- **eBay**: "The Pig."

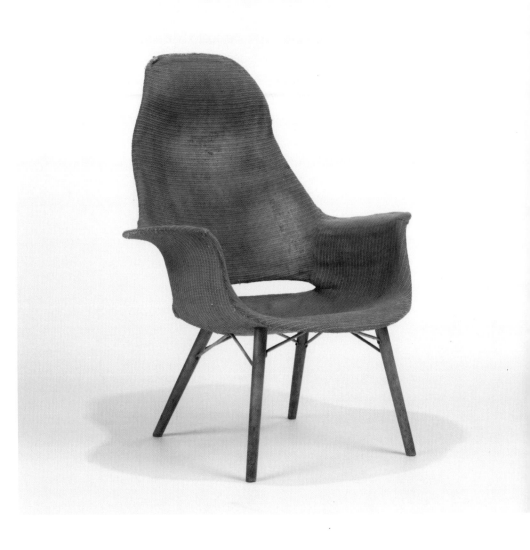

Charles Eames and Eero Saarinen, High back armchair
from the Museum of Modern Art Organic Design Competition,
Haskelite Corporation and Heywood Wakefield, USA, 1940

- **First shot**: When you see someone buy something great and you want "first shot" at them "flipping" it to you.
- **Flea**: Flea market.
- **Fleas**: People at a flea market, used derogatorily by the locals.
- **Flip**: To sell something quickly and efficiently for a profit.
- **Full vig**: To get retail price.
- **Gilpinated**: Heavily restored.
- **Half-a-Plate Stan**: Means it's secret, that you will keep your mouth shut.
- **Holy grail**: The ultimate "score."
- **Kiss of death**: When something has a detail that kills it, which if it didn't have, it would be fine. "That Eames LCW would have been amazing, but those drill holes in the back are the kiss of death."
- **List price**: The sucker's price, or listed price, see: *full vig*.
- **Merch**: Stuff for sale.
- **Net price**: The price minus a discount.
- **Pennies**: Meaning you paid almost nothing for it.
- **Pick**: To find something at the source for a low price. "I picked that Nelson table from a garage sale in Yonkers, and 'flipped' it to that dealer on Lispenard St."
- **Picker**: See also: "scout." A person who sources merch for dealers out in the wild and drives it into the city for dealers to buy.
- **Red box**: Place you put new, unknown merch until you find out what it is, so as to avoid costly mistakes related to "flipping" it too quickly. I know a dealer that flipped a piece of ceramics at an antique market and thought he had done well until he got home and saw it in a Sotheby's catalog for 50 times what he sold it for…he promptly vomited!
- **Refin**: Refinished.
- **Scout**: See also: "picker." A term from the Larry McMurtry book, *Cadillac Jack,* about a picker. Get it, it's a fun and easy read.
- **Score**: To find something for way, way below its value.
- **Smalls**: Items that can fit in a box, and if you are a true flea

Donald Judd, Copper armchair, Lehni, USA/Switzerland, 1984

market dealer, that will be a lidded banana box. You will also wrap all of your smalls in adult diapers, no I am not kidding. Bubble wrap is for suckers!

- **Sweet deal**: A deal that you would only give to family and friends, or that's what you want someone to think.
- **That's for buying, not for selling**: Something that a dealer will always buy because it is too cool to pass on, but will be super hard to sell.
- **Trash pick**: Finding something in the garbage or on the side of the road.
- **Vernissage**: The opening party of a fair. From the French term for "varnishing," meaning it was the last thing an artist would do before the opening.

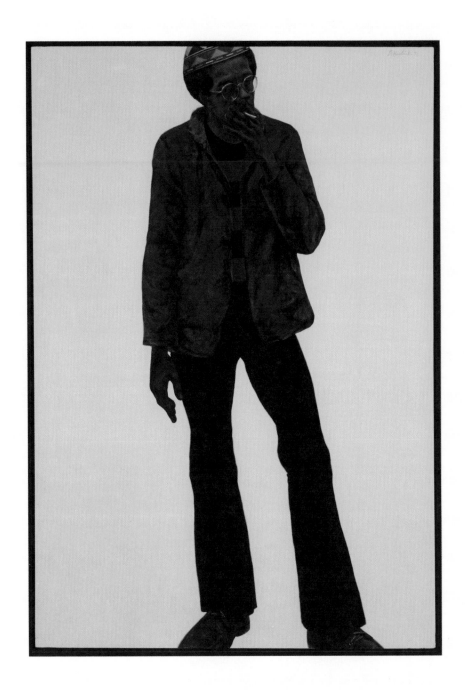

Barkley Hendricks, Stanley, USA, 1971

Flea Markets

Always go very early, when the dealers are setting up, and when I say early, I mean at least an hour before sunrise, because most outdoor flea markets start setting up then. If they open to the public at 7:00 AM, show up at 5:30 or earlier. (90% of all deals are done and gone by the time the public gets in.)

If they ask you to pay to get in early, do so: it's always totally worth it. Even if they ask you to pay the price of a booth, which will usually only be a few hundred dollars or less, it can be worth it if you are a pro. The early bird definitely gets the worm.

Once in, be respectful of the dealers setting up and unloading, as some can be quite grouchy due to the early hour and lack of coffee!

If you see something you like, ask about it nicely, be curious about it, say it's great, cool, amazing, whatever, but always say something positive. If you think dogging the merchandise will get you a better deal, you are *way* off. This person liked it enough to buy it, repair it, polish it, and drag it all the way to the flea market. Compliment it.

The next step is to ask, "What would your best price on this be?" If they say $125, counter with: "Would you do $100 cash?" (You must always have cash.) 75% of the time, if you are polite, nice, and complimentary of the piece, the dealer they will say yes. Again, again, again: Saying, "I'll give you…" will get you nowhere.

Once you have agreed on the price, get it out of the booth ASAP, especially if it's something good or something that was a bargain. The last thing you want is people pestering the dealer all morning about something he blew it on. That won't help you the next time you see him, either.

Unless you are a pro, and even then I hesitate to ever do this, never "flip"

Alvar Aalto, Cantilevered chair, Finland, c. 1945

something to another buyer at the flea (who will 95% of the time be a dealer) even if the profit is high. You paid $100 and someone is offering you $300? Pass; that means you have a find. So take your time, take it home, and do your research.

Essentials to bring

- **Flashlight**: If you don't need a flashlight, you're at the market way too late!
- **Super comfortable shoes/boots**: You will be walking for miles and miles.
- **Sunscreen**: Even a wide-brimmed hat can't save your ass from Señor Sun.
- **Cash**: It truly is king, especially with the types that set up at a flea market. Pull out a credit card and you'll get laughed at.
- **Layered clothing**: Mornings are cold, midday is hot. Especially out West. Everyone seems to forget.
- **Hat**: Wide-brimmed and as unfashionable as possible, for more flea street cred.
- **Positive vibes**: Yup!
- If it's a multi-day, outdoor fair: **bug spray, plenty of water, and Desitin**, which is diaper rash stuff. (You'll thank me later.)
- **Big bag**: To carry your spoils in afterwards.
- **Magnifying glass or loupe magnifier,** if you're over 40!

Ettore Sottsass, In Praise of Epicurus chair,
Renzo Brugola for Blum Helman, Italy, 1987

Picking

Anyone can "pick," but to be a "picker," you need to find and then sell, other-
wise you're just a shopper. I was a picker for years before becoming a dealer.
What's the difference? A picker buys and flips, meaning he sells quickly what
he finds and not for all the money, meaning he has to sell it to a dealer at a
discounted rate so the *dealer* can then try to sell it for all the money, which can
often take a year or more.

A good picker has something for less than a week, a great picker has some-
thing for less than a day, incredible pickers sell the item before they even get it
home. Buy it, sell it, move on, and sometimes without a profit (which is obvi-
ously not ideal). Sometimes the smart move on a mistake is to get the money
back as soon as possible, and move on to the next "score."

An effective picker will give a dealer room to double or triple his money.
Hopefully the picker did that too, or better. A bad picker is one who doesn't
understand that the dealer is there to buy over and over and over again, and
that if he prices things too high, and the dealer has his pieces for too long,
or doesn't sell them at all, he isn't gonna buy from him anymore. When I was
picking, if I bought a vase for 10 bucks that I knew was worth 100, I would
sell it for 30 to the dealer who would mark it 120, sell it for 100 and more than
triple their money. That is why I truly had dealers chasing me down the street
if they saw my van.

Where to pick? Everywhere! As I would tell people when they would ask
where I found stuff, I would say, "From the side of the road to Sotheby's," and
I meant it. I have literally trash-picked things worth a thousand bucks and
bought things at "high-end" auctions for "pennies" that were worth tens of
thousands. It doesn't happen often, but when it does, you need to be ready,
which means being everywhere at all times. That is the life of the picker.
Leave no stone unturned.

Carlo Scarpa, A Bugne vase, Venini, Italy, c. 1935

My Favorite Picking Stories

"Half-a-Plate Stan"

One day my friend James asked me to drive down to Philly to appraise and possibly buy a collection of art that he had been approached about, telling me there would probably be some cool furniture, too. I love James, so it was an easy yes, and he picked me up later that week and we headed down in his van, with pretty big expectations as the names the client dropped were greats: Calder, Miró, Arp, Dalí, etc. But these names also threw up a *big* red flag for me, as they are ones that the fakers and fraudsters love.

We arrive at this amazing circular, 60s-modernist high-rise building on the city's edge and head up to the penthouse, which took up the entire floor. The apartment was beautiful and looked like an early-80s time warp, but I knew immediately that we were in trouble. The furniture was no-name "condo-modern," and the art was everywhere, but without even taking them off the wall I knew they were bogus. All had their "COAs" (as I've said before, a big red flag for me, and I was right as these turned out to be bogus), and they were in god-awful ornate, gold frames. Everything was exactly the same size and looked like it had all been made at the same time. They were all from a now-defunct Philadelphia gallery with other locations in New Orleans, Las Vegas, and Hollywood (another huge red flag).

As our host started telling us his story about how he had collected all this art, my heart started to break. Let me describe him: His name was Stan and he was a retired Army colonel who had served time in the Korean War and had been given a Purple Heart for his valor there. He was 89 years old but still 6'6" and very, very imposing at first glance. A man's man—sweet, if not a little tough. He told us that he had spent hundreds of thousands of dollars at this gallery, and that he had gotten great deals and was reluctant to sell, but his

Carlo Mollino, Important coffee table, Model 1114,
Apelli & Varesio for Singer & Sons, Italy, c. 1950

wife's health was bad, and they were moving to an assisted living home so he was downsizing as it wouldn't all fit (the walls were covered). We did our best to hide our sadness for him and his wife that all of this art was fake. They were almost all "limited edition" prints and Stan had really been taken for a ride. *At least he was going to get a great price for his apartment*, we thought. So we did our "pretend" assessment: measuring, photographing, and describing, so we could give him the bad news via email.

After we were finished, he took us into his study to show us some pictures from Korea. Man, Stan was really a stud. He looked like he was 6'10" back then, and must have been a hell of a soldier. James asked him how he stayed in such great shape and he said: "James, I go to dinner with my friends and I order whatever the hell I want. Then I tell the waitress, 'Sweetie, bring me an empty plate,' and when she does I cut the food in half and hand the plate back to her. They always look puzzled and ask me what I want them to do with this extra plate and I tell them to do whatever the hell they want with it, I'm not eating it! That's why they call me 'Half-a-Plate Stan.'" I then asked Stan if he had any advice for us and he said he had four words: "KEEP YOUR MOUTH SHUT!" he bellowed. He said if we followed those four simple words we would go far, but probably not as far as his son who was head of surgery at Temple University Hospital!

So why this long story? Because what Stan said is key to not only keeping fit, but for searching out and finding deals and steals in the cutthroat world of art and design. It has resonated so strongly with me and my tight circle of friends that we all know if someone says, "Listen, this is 'Half-a-Plate Stan,'" that it is really something you can't repeat. But if you were Stan, you wouldn't even say that! So keep your mouth shut, look in every box lot, and you will go far and find amazing stuff!

Adolf Loos, Lounge chair, Austria, 1906

"26th Street Nevelson"

I remember a hot, sunny late-morning around 8:30 a.m. (remember, we start shopping at 3:30-4:00 a.m.) at 26th Street. When I thought it was all done and it was time for breakfast and a nap, I got a call on my walkie-talkie. Yes, we used walkie-talkies! With belt clips! In fact, some people called me and my then-partner "Walkie" and "Talkie." Cute, right? Not! Anyway, I made my way over to a truck and it wasn't unloaded but my partner had gotten word that there was good stuff inside: 50s art and furniture from an Upper West Side psychiatrist's office. The truck driver was standing by the gate, but refused to open it until his boss got there.

So we waited and waited and as we did, other dealers—all our competition—started to linger as well, wondering what the hell we were doing way past our "bedtime." They were no dummies (well, most weren't), and now a scrum was starting to form behind the truck, probably to the delight of the driver and his "boss." So more waiting, almost an hour, and we finally said, "Open it up and give us a peek or we're all leaving." So he called the boss and without saying a word he started to unpack. And we started to freak out! The first piece was an Arredoluce three-arm floor lamp, the hottest lamp in NYC at the time, and it was in all-original, beautiful condition just like it had been sitting in an office since 1955. Next off, a pair of Pierre Jeanneret for Knoll "Scissor" armchairs, again in perfect condition with original, orange wool Knoll upholstery and early Park Avenue labels. Then a pair of Franco Albini rattan stools, and other cool stuff which we were putting into a pile to the chagrin of all the other dealers who were standing there waiting for us to "pass" on something...but we were taking everything.

Around this time I noticed a flat-black painted panel, a wooden assemblage, and asked the guy how much, and he again deferred to his boss, who still wasn't there. The boss said $1,200 and I got excited, but then the driver/unpacker said that that was just one of 15 panels of all sizes. I said I would take it and started

Pablo Picasso, Buste de Femme, Spain/France, 1942

drooling as he unpacked all of the other panels, which we started to arrange on the ground until it got too big. What were we looking at? Well, to me it was 100% by Louise Nevelson. This was going to be a major score and we couldn't believe it. The "boss" got there, saw the crowd, saw the stuff, knew that we would take it all, and promptly started to hem and haw about the prices he had given us over the phone and said it was much nicer than he thought, claiming this was the first time he had seen the stuff—behavior which usually lead to us walking away.

But this load, especially the Nevelson, was too valuable to pass up, even as he almost doubled his price of $8,000 to $15,000 for it all. Not happily, but satisfactorily when looking at the big picture, we packed up our loot and took it to our gallery, Mondo Cane, which we had just opened on 22nd Street in Chelsea. We were about to get our first taste of how the art world works, and what a long road we would have with this amazing wall panel...

So, flash forward six months and we had sold the lamp, chairs, and stools for more than we paid for the lot and were already in the black, and we still had the "gravy" of the Nevelson piece; but getting documentation by way of the psychiatrist was proving super difficult. Once we had exhausted that line, we moved on to auction houses, who all wanted it but wouldn't touch it without provenance. The story all worked in theory: the panel was custom as it was designed to wrap around a wall, the furniture was all period-correct to the panel, and all the pieces sure felt like they came from the same place, but without proof, all we had was a cool, matte black, wooden assemblage that we would do fine with, as a decorative panel, but we wanted Louise Nevelson money, not "in the style of" money.

Every road we went down we were met with the same problem: we needed provenance, and a story, even if it was a plausible one, one that made sense to us, just didn't cut it when it came to selling it for "real money." So as a last resort, and I say this because I had had friends get burned by them, we went

Gerrit Rietveld, Zig Zag chair, G.A. van de Groenekan, The Netherlands, 1932

to the gallery who represented the estate. We sent photos, they wanted to see it in person, so we drove to the gallery and set it all up and three very serious men in suits looked at it, smiled, and one by one walked back into the gallery. They said they would be in touch, which they were, with a curt, "Thanks for coming by," and nothing else: The kiss of death for a piece of artwork.

We were so bummed, but I refused to sell it as a decorative panel, as my partners wanted to do. So it still sits to this day in a warehouse in Williamsburg, except for the one panel that hangs on my wall because I know in my heart that one day, I will find that documentation, that vintage photo in that obscure Louise Nevelson catalog. This is what keeps me searching, keeps me researching, and even though this story doesn't have a happy ending (yet), it's stories like these that keep me motivated to stay in the game.

"The Horse Bookends"

At Brimfield many years ago, I stumbled into a tent on a super hot afternoon, and into a booth that had tables filled with items almost in a pile but not quite, every inch of the tables covered. My eyes immediately went to a pair of sur-realistic horse bookends and my stomach fell. I nervously asked for the price, having more than a few times asked a price for something in a junquey booth only to have it be amazingly, stupidly expensive. The proprietors were an elderly couple in their 70s.

"Forty dollars for the pair."

I couldn't have reached for my roll of bills any faster, and no, I did not ask for a better price.

The gentleman then proceeded to tell me that if I liked these bookends I would have *loved* the NYC apartment they came out of. "This apartment was full of

Richard Hamilton and Marcel Duchamp, The Sieves,
UK and France, 1971

crazy, weird stuff like those bookends," he said. I immediately asked what else on the tables was from the apartment and he shook his head and said, "Oh no, nothing else, everything was so expensive that I couldn't afford it." And I was thinking, if he just sold me these for 40 bucks, what did he think was expensive?

I still think of what was in that apartment to this day. But you want to know what I sold them for, right? I consigned them to Wright in 2002 and they were estimated at $10–15K ... and sold for $28,750! Needless to say I was very, very pleased, until my Wright contact told me they were unable to get a second bidder on the phone who was prepared to go to $50K! Ugh!! But that's the auction game, ups and downs, excitement and disappointment, even when you hit a home run!

"Best 'Trash Pick'"

I have a friend who is an amazing picker, we actually call him the "Super Picker," and one day he was driving down the road near his house in Northern New Jersey when he slammed on his brakes and nearly caused a traffic accident, because he saw a pile of what someone else thought was garbage but he knew was gold. 99% of people would have driven right by, but my friend knew the distinctive work of Paul Evans—a 1960s American furniture designer and artist from New Hope, Pennsylvania.

My friend spun his car around and, with superhuman strength, loaded this bronze and wood, four-door cabinet with slate shelves and top, into his vintage Volvo. How he did this, I don't know, but I was almost as excited as he was when he sent me photos, as I knew I was going to buy it. It was also in amazing condition, and even signed and dated. He sold it to me for $15,000 and similar pieces have sold for up to $50,000. The world record for a Paul Evans credenza is near $400K. This really has to be one of the very best

Isamu Noguchi, Rare and important chess table, model IN-61,
Herman Miller, USA, 1944

trash picks for modern design that I have been a part of, and I urge all of you to keep your eyes peeled, as you never know when or where that score of a lifetime may present itself!

"Cat Box"

I was at a country auction in western North Carolina that posted that they would be selling some pretty nice modern furniture. I got to the ramshackle building in the tiny town and previewed the pieces, which were better than expected. As I was killing some time, waiting to have someone help me turn a table over to look at a label, I decided to dig through the box lots. As I was monotonously flipping through the fifth box of cat prints, I see this beautiful little oil painting on board with its original frame. But there was one problem. The non-box lots I wanted were in the first hour of the sale and the "cat box" lot was going to go off at least six hours later at the very end of the auction. I even asked the auctioneer if he could auction it early and explained that I was from out of town but he said he couldn't, that it wouldn't be fair, which it wouldn't have been, but I had to ask.

So, I bought what I wanted of the furniture, and then killed the six hours until the lot came up. When the first of the five boxes finally hit the block, they were selling for 25 cents to two dollars for each box! I was psyched as I had done a little research during the downtime, and had found out that the painting was by an obscure (at the time) American surrealist, Gertrude Abercrombie, who is called "The Queen of the Bohemian Artists." She was a free spirit from Chicago who married an ex-con, drove a 1920s Rolls Royce, dressed like a witch, and was close friends with the jazz greats of the time. Dizzy Gillespie performed at her wedding, and Charlie Parker was there along with Sarah Vaughan. Anyway, when the lot came up I was prepared to go up to a thousand bucks but the other lots were going for so little that I got really excited. The bidding started at five cents (I'm not kidding), and slowly went up. But once it reached

Anni Albers, Smyrna rug, Jack Lenor Larsen, Inc., Germany/USA, 1925

ten bucks, I knew, or thought, someone else also knew what was buried in that box. We creeped up and up painfully slowly until we got to 200 bucks! I couldn't believe it but was happy to get it. The auctioneer announced that I should talk to the under-bidder in the front row as he said that he was pretty sure "we were both after something different." So I did, and this super tall, super skinny, kind old man in overalls said he ran a shelter for cats and wanted the prints to decorate it. I said all I wanted was the small painting, and he said all he wanted were the photographs behind glass, so I grabbed the painting out of the box and handed the rest to him, I thought he was gonna cry! I still live with the painting today and have no intention of selling it anytime soon—I feel the market for this surrealistic material, especially by women, has nowhere to go but up.

"Saarinen Silver"

I was walking back from the dealer "hospitality" shack—basically a clean toilet, which at Brimfield can be a savior as everyone else has to use the porta-potties, and we know how gross and disgusting they get—at Brimfield one May. The shopping was pretty much over for this field, as the public was about to get in and we had been shopping since 5:00 a.m. It was almost 9:00 a.m., and I was chatting to my business partner at the time and not looking at the tables of merch that were on each side of us while we walked down the dirt road to our booth, when I saw a dealer probably 20 yards ahead of me pull a small silver bowl out of a box and set it on her table. I don't know how I knew from so far away, but I did my best run/walk so as not to draw attention to myself and literally grabbed the bowl just in time, right in front of another knowledgeable dealer who was perusing the table. He saw it in my hands and made a face! The price tag said, "Silver bowl $110." I quickly handed her $120 and waited for my change, but she didn't have a 10 spot so she said $100 was fine. I didn't argue, as I wanted out of there ASAP (after asking her if she had anything else from the house). I immediately tucked it in my shoulderbag as my astonished business partner stared at me and said, "How did you

George Nelson & Associates, Pretzel armchairs, Model 5890,
Herman Miller, USA, 1952

see that? How did you know what it was? What is it?" What it was was an extremely rare piece of American Art Deco silver by Eliel Saarinen. He had designed it for the Charter Silver Company while he was at Cranbrook and it had been exhibited at the Metropolitan Museum of Art's show, "The Architect and the Industrial Arts" in 1929. It was the smaller of the three sizes that were produced in a very small run. I consigned it to auction and it brought $10,620. Another example the exact same size sold six years later for $74,500! Timing is everything with both scoring and selling.

"Rudder Table"

It was a nice early spring morning at the 26th Street flea market and I was walking around with the legendary flea market dealer and painter Robert Loughlin. Robert was famous, maybe I should say infamous, for many reasons, the least of which was that he was always drunk, high, or both when he shopped. He was also the most knowledgeable dealer I've ever known, but he was a TOTAL MESS 95% of the time.

We were walking along scoping out the junque and gossiping (Robert loved to gossip), when we saw a truck turning onto 6th Avenue from 25th Street. He blurted out some name like I should know who it was, and we both ran to the truck to position ourselves directly behind it so we would have first shot at the pieces as they were unloaded. We were the first people there but, very quickly because Robert and I were both there, a small gaggle of aggressive dealers gathered behind and around us. It was an unspoken rule at 26th Street that the first people there get first shot, and if they pass, and only then, can the people behind them fight it out.

No sooner had the truck gate rolled up than Robert shouted out to the driver, (slurring of course) "How much is that blonde leg table? I want that table. How much?!?!" Robert was not subtle. I immediately focused my flashlight beam

Irving Harper, Untitled (Mask), USA, c. 1960s

into the very back of the jumbled, blanket-wrapped pile in the back of the truck's dark interior. There at the very top of the pile was the distinctive "rudder fin" leg of an early Isamu Noguchi coffee table for Herman Miller. At the time this was a "holy grail" piece, and I whispered to Robert, "I want first shot." He ignored me and I grabbed his arm and repeated it. He said, "Okay, okay, girlfriend!!" The guy told Robert the table was $350 but by the time it came off the truck, the dealer, who was no gem of a person, said it was now $1,200 as it was garnering so much attention. Robert was laughing and making fun of the guy for being so unscrupulous, but he didn't care. I remember Robert flipping the table over onto his head and walking it over to his truck and placing it in the back with me close behind. He told us to meet him at his trailer in New Jersey. (He lived in a Spartan aluminum trailer with his "brother," Gary. But that's a whole 'nother story.)

Later that morning we drove out to the trailer. We pulled up in our van and Robert had the table sitting out on his concrete pad of a patio and he was really amped up. I think we paid Robert $8K for the table and later sold it for $15K, but the same form has brought up to $66K. So get to the market early, learn from the masters, and always ask for "first shot"!

"The One That Got Away"

It was a miserable, cold, rainy Brimfield in early May, and I was slogging through the mud at the "Heart of the Mark" field in a downpour. It was raining like "cats and dogs," but when has that stopped anyone at Brimfield from setting up and trying to hawk their wares? I approached the setup of some dealers from Buffalo, New York who usually had cool stuff. Sitting in a mud puddle to the side of a table was a small sculpture of a snail on a plinth that was painted white. I couldn't tell what the material was but it was so cold, wet, and muddy that I kept my gloved hands dry in my pockets and stared at it for a minute. *Looks a little bit like early Russell Wright*, I thought. My walkie talkie squawked, and distracted, I moved on.

Imi Knoebel, An meine grüne Seite, Germany, 2007

Thirty minutes later, it was still pouring, the sculpture was now deeper in the mud, and I stopped to look again (I should have taken this for a sign). I remember staring at it and thinking it was kinda surrealistic and cool but I still kept my hands dry, warm, and mud-free. Big mistake. On my next loop around, the sun had started to peek out, warming the field, so I went back to look at the snail for the third time, but of course it was gone. *Oh well*, I thought. I asked the dealers if they had sold it and they said yes. I asked them if they had had it long and they said yes, it had been in the window of their shop for a year and that is why the paint was peeling off of it (that, and the pouring rain!), I asked how much it was, ($250,) and figured for $250, peeling paint, and sitting in the window of a busy shop I couldn't possibly have made a mistake.

A few hours later I was having a beer in our booth when a dealer friend walked up, all excited.

"I just found a Jean-Michel Frank sculpture by Albert and Diego Giacometti! I can't believe it! It was just sitting in the mud."

My stomach edged closer to the edge of the pit that was forming as I asked, "So, Bill, what does this sculpture look like?"

"It's of a snail, a surrealistic snail."

My stomach started to fall.

"...Was it painted white?" I asked, hoping helplessly that he would say black, pink, anything but white.

"Yes! How did you know? Yes, peeling white paint. Did you see it?"

"No, it was just a lucky guess."

I don't think he believed me...stomach into the void...

This Bill character was legendary for attributing weird cool things to great designers and sometimes he was right, but 95% of the time he was just dreaming. So I thought, *it's probably just wishful thinking on his part*.

Flash forward six months and everyone is talking about Bill's find. So the next time I saw him I asked him about it and he gleefully told me that the sculpture was signed, that it was painted bronze, not plaster as they normally were, and

Max Bill, Sgabilio stool, Zanotta, Switzerland/Italy, c. 1950

that he had it on consignment for, wait for it: $100,000.

"It's worth much more," he said, "but I need the money."
Much more indeed, in today's market I am guessing it would bring $500-750K, if not more. It still hurts to this day, but I learned (the most expensive way ever) these two important things:

- Always pick up and inspect *anything* you find visually interesting, even if it is in the pouring rain covered in mud in a field in Western Massachusetts.
- Always buy books, even on designers you feel like you will never find. There was a Jean-Michel Frank book that I looked at numerous times in bookstores that I never bought because I thought I would never find anything by him. WRONG. This also explains why the piece looked kinda familiar, as a plaster version was featured on a full page in that book.

"Mystery Desk"

I was shopping the set-up of the LA Modernism show when it was in the amazing Santa Monica Auditorium, on a perfect, cloudless Southern California day with my then-business partner, when I spotted two guys I did not know carrying a beautiful and very unusual desk. I beelined toward it and said, "How much for the desk?" and they said $6,500, which at the time was a lot of money, and not at all what I was expecting them to say. I asked what they knew about it, all the while not leaving their side as they carried it in, as I had a feeling about this desk even though I had no idea what it was. They said they also had no idea what it was, but it came out of a good estate (I had heard that line about a million times so that didn't help). I asked if it was marked and they said yes, but they couldn't read it well. I consulted with my partner and said we had to buy the desk even though it was expensive. He made a deal with them for $5,500 and we put it in our booth. I would usually put something like this in storage or our van and

Ralph Rapson, Rocking chair, H.G. Knoll & Associates, USA, 1945

wouldn't let anyone see it, but in this case I was looking for info and was anxious to see what people thought. If they knew, they were keeping it to themselves, but I really don't think any of those experts at the show did know.

When we got it back to New York, I sent photos to Wright and Christie's. Neither house knew what it was, and both admired it but weren't willing to take it for auction until I figured out what it was. Skip ahead six months and a decorator I knew who was famous for his tall tales but had a photographic memory, walked in, and I said, "Hey, I have a desk to show you." He took one look at it and said, "It's Arne Jacobsen." I said I didn't think it was (even though it looked like him), as I had exhausted all the Arne Jacobsen books and catalogs, as had the two auction houses. He said it was 100% Arne Jacobsen and then told me exactly what book it was in. I just so happened to have the book, and was kinda looking forward to proving him wrong, when there it was! Arne Jacobsen for the Danish Consulate in NYC! I couldn't believe it. So, off to auction it went, and I remember watching it live on my laptop, when that was a novel thing. It was estimated $10-15K and it just kept going up and up until it sold for almost $60K! What did I learn from all this? Trust your gut, the auction houses don't know everything, and outside experts can come in handy even if they are full of shit 90% of the time!

"NASA Photographs"

Always use a trip home to see relatives as an excuse to pick. Not only will everything seem fresh and new to you, but you might actually find something and pay for your trip, or even more. I routinely pay for all my trip expenses this way even if I don't try very hard, but I guess it *is* my job after all. One recent and amazing example of this was when I flew down to Western North Carolina to visit my then-100-year-old grandmother. She lived in a small town nestled in the Blue Ridge Mountains and there was a nice antique mall in an old five-and-dime store which I always visited, with some pretty nice results.
This time I didn't find anything, and was about to leave, when I saw the apple

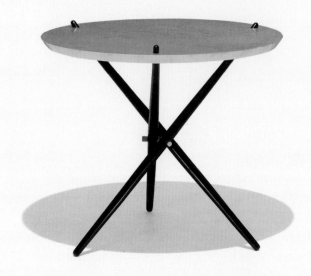

Hans Bellmann, Occasional table, Knoll Associates, USA, 1948

crate-type boxes near the front door that you see at a lot of antique malls, where a dealer will put paper items such as catalogs, old maps, photographs, and other ephemera that is hard to otherwise display. They are usually in vinyl sleeves with a price tag on the outside. Since I was bored, and not ready to head back up the mountain, I started to flip through the stuff and almost immediately came upon a small binder of color photographs of astronauts on the moon. I didn't know for sure what mission it was, but it ended up being Apollo 11, the first NASA mission where man set foot on the moon. The photos (there were 22 of them) weren't signed, but they were a vintage Kodak paper and had a nice patina, so I knew from my experience as a photographer that they were old. The table said $22, and I figured $22 each was more than fair and I proceeded to the checkout. The lady at the register rang it up and as I got ready to hand her the cash, she said, "That will be twenty-three dollars and five cents."

I was getting ready to hand her five crisp 100 dollar bills! I said, "Are you sure? It says 22 dollars each."

"No, hun, that's for all of them, I know the dealer!"

Talk about a pleasant surprise! Anyway, now I knew that I had "scored," but I would have no idea how big until a few years later, when I actually got around to researching and framing them, then putting them out for sale at a fair. I'll cut to the chase. I sold all 20 (I kept two) almost immediately, with 12 going to the permanent collection of SFMOMA, and let's say the price for the group ended up being in the mid-five figures! Lessons here? Always try to hit the spots when you are on vacation or traveling, go through the underwhelming-seeming bins, and do your research!

"Not a Bracelet"

This unfortunate incident happened maybe two decades ago at a Pier Show in Manhattan. I was cruising the set-up looking for something to score, but things were slow (I think it was lunchtime), and I was tempted (bored actually) into look-

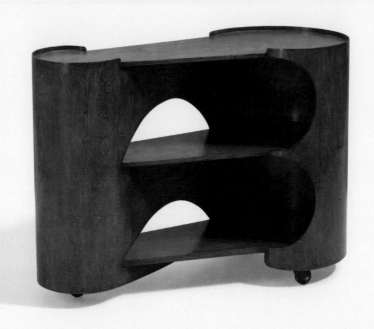

Gerald Summers, Rare tea trolley, Isokon Furniture Company,
UK, 1937-1938

ing at a jewelry dealer's showcase, which was filled and piled high with all sorts of costume jewelry. My eye immediately went to a pair of "bracelets" that were made of folded and hinged aluminum. They were super cool and I thought my girlfriend at the time would like them, although it seemed that the opening for one's wrist seemed a bit small.

I asked the dealer how much they were and what she knew about them and she said, $125 each and that they came from an estate and the woman said she bought them in Brazil. That wasn't much for me to go on, but they were so cool I asked if I could run them over for my girlfriend to see as she was in our booth helping with set up. She loved them but couldn't get them on her wrist, and she had very small wrists. So I thought, why buy a "bracelet" that no one could wear? $250 for the pair was cheap for something so great (little did I know), but if I couldn't sell them why would I buy them, right? So I returned them to the dealer and I remember they sat there until the show opened and then they were gone.

Flash forward to 2014 and the Lygia Clark show at MoMA. My stomach dropped when I saw a pedestal with the nearly identical "bracelets." I felt like an idiot—they were sculptures, not jewelry! A lot had changed in the 17 years since I first saw them in that showcase, but man oh man why didn't I trust my gut and buy them then?

It still makes me a bit queasy every time I see one now. I'm not sure what two of the Brazilian Modernists's sculptures would go for these days, but I'm sure I would have to add nearly three zeros to the price!

Moral of the story? Don't take one's description ("bracelets") at face value; don't let the environment something is currently in affect your view of it, and TRUST YOUR GUT!

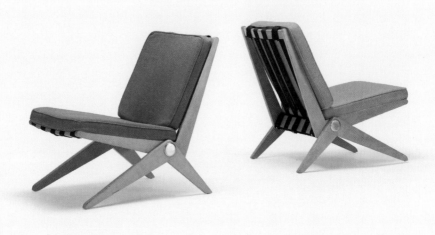

Pierre Jeanneret, Scissor chairs, Knoll Associates, Switzerland/USA, 1950

Self-Education

Books

You can NEVER, EVER go wrong buying a book on an artist or designer you like or are interested in.

Buy the hardcover when you can, at a museum, bookstore, or on Amazon. When I was a student, I always bought the paperback because I needed to save money, but I regret that now because paperbacks get trashed and hard-covers are always worth more.

Amazon is a favorite place to buy books because you can get *screaming* deals if you aren't a "Condition Queen" and are just looking for great information. Knowledge is power.

Library copies are 50–90% cheaper than a similar book. Sometimes the copies are in great condition because a library covered them in Mylar, and design titles were never checked out by some messy nerd for a science fair paper. So if you don't mind a Dewey decimal system label and a date stamp tab in the back, these are an amazing value. And if you don't plan on selling it and are just look-ing to learn and have a great reference, these are the way to go.

Some of My Favorites

- *Mid-Century Modern: Furniture of the 1950s* by Cara Greenberg, Harmony Books/New York, 1984: The start of it all. The first serious book about 50s design. The Bible for new collectors, then and now.
- *The Machine Age in America: 1918-1941*, The Brooklyn Museum/Harry N. Abrams, 1986: The exhibition catalog that changed my life.
- *Craft in the Machine Age 1920-1945: The History of Twentieth-Century*

Dankmar Adler and Louis Sullivan, Elevator door from the Chicago Stock Exchange,
Winslow Brothers, USA, 1893

American Craft, **Harry N. Abrams, 1995**: A deep dive into American Design, focusing on craft.

- *Organic Design in Home Furnishings* **by Eliot P. Noyes, The Museum of Modern Art, 1941**: The pieces in the exhibition were so cutting edge at the time that almost none of them sold.
- *1000 Chairs* **and** *1000 Lights* **by Charlotte and Peter Fiell, Taschen, 2013**: These books have lots of mistakes and misattributions but are chock-full of very useful info too, and are kind of a must for any library.
- *Esempi di Arredamento Moderno di Tutto Il Mondo, (Examples of Modern Furniture from Around the World)* **catalogs, by Roberto Aloi, Ulrico Hoepli Editore/Milan, 1950-1959**: These scarce catalogs were intended for the trade at the time they were published and contain amazing examples of furniture and design from all over the world, but focus on mid-century Italy.
- *Domus 1928-1999. Vols. 1-12.* **Edited by Charlotte and Peter Fiell, Taschen, 2006**: This reprint is the best of the best of the best of *Domus*.

Magazines

—Contemporary—

- *Modern*: Published by the same crew as *Art in America*, and owned by Peter Brant, this is the only design mag (quarterly) that covers both vintage and contemporary.
- *Dwell*: Not a fan. Cookie-cutter interiors to the point that they seem to be self-parody, but they do have a strong reach.
- *Apartamento*: Friends of mine publish this and I am proud of them. Probably the magazine I most look forward to reading. I also coined the term "Apartamesso" as the early interiors were always so lived-in as to be funny, like the photographer dropped in unannounced after a drunken pizza party.
- *Frieze*: My favorite "reader" art magazine and the mother of the Art Fair.

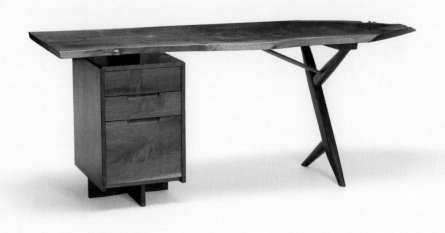

George Nakashima, Conoid desk, USA, 1954

- *Artforum*: My favorite "looker," I find the writing a bit obtuse and "art speak," but the ads are *fabulous*!
- *PIN-UP*: Felix Burrichter, the publisher, is also a friend and this magazine is unique for its unconventional perspective and coverage of architecture and contemporary design.
- *Surface*: An up-and-comer, and yes I am also friends with the editor! If a magazine can put Kanye on the cover and I still buy it, you know it's good.
- *Domus*: *The* Italian Design magazine of the 20th century. Gio Ponti was the editor from its inception in 1928 up to 1979, stopping only months before he died. Still exists today.
- *The World of Interiors:* The bible for fancy, funky interiors from, you guessed it, the world. If you're looking for the coolest fisherman's cottage on the Isle of Man, this is where you'll find it.

—Vintage—

- *Interiors*: The American version of *Domus*, filled with amazing info and terrible photos because of the cheap-ass printing.
- *Interior Design*: First published in 1932, it's basically *Interiors* lite, but still worth grabbing if you see a box of vintage ones, especially copies from the 40s and 50s. The magazine is still published today but is very trade focused.
- *Craft Horizons*: First published in 1941, the title was changed to *American Craft* in 1979. Thin, but always has something or someone amazing profiled.
- *Ceramics Monthly*: Same as above. It's been around since 1953.
- *Nest*: My favorite magazine of *ALL TIME*. It ran from 1997 to 2004. The *Apartamento*s and *PIN-UP*s of the world would not exist without Joseph Holtzman's singular vision and personal pet project that almost bankrupted him. Rumor is he sold a Henry Moore sculpture to keep it afloat!

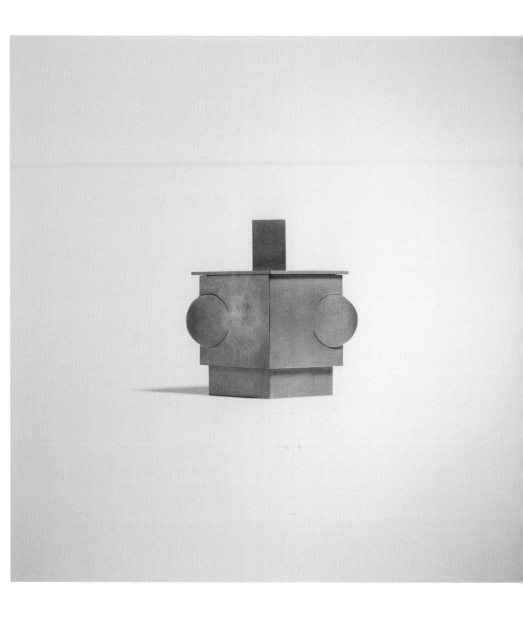

John Prip, Lidded box, USA, 1983

My Favorite Instagrammers

twin_pix
> Features pictures of design that look remarkably similar. A favorite of mine since I believe that "it's all been done before" and that most people are lazy, rip-off artists and need to be called out. This account does that brilliantly and proves that ignorance is not bliss!

whos__who (yes, that's two underscores)
> Same as twin_pix but with art.

james_zemaitis
> The former head of design at Phillips and Sotheby's (and one of my trusted resources) started a project to document his top 1,001 pieces of modern design—he even has a soundtrack for each one! This is a book I will buy when it comes out!

casafutura
> A hilarious, deadpan account of one Milanese's efforts to find the perfect apartment.

arthandlermag
> Huge fails and spectacular feats in the fascinating world of handling art.

ucantalwaysgetwhatuwant
> A great friend with a great eye and a keen European sense of irony and humor.

_di_ma
> Modernist architecture, mostly Brutalist, and mostly things I have never seen before, which is always a plus.

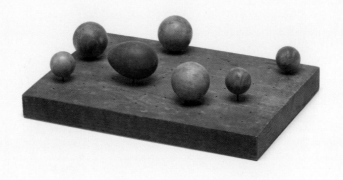

Hugo Weber, Kugelspiel, Switzerland/USA, 1936

emmalouiseswanson

A former employee with a sharp eye and a wry sense of the absurd in social media culture, who uses Instagram as a medium for her art and a vehicle for wearing her heart on her sleeve.

subwaycreatures

Documents the freaks and weirdos who ride the underground subway systems around the world. Gross, disgusting, disturbing, and brilliant.

codyhoyt

One of my artists who gives you a rare glance into the intimate artist's studio and the magical things that happen there. Most people hide their techniques and secrets, Cody doesn't and that is what is amazing.

alice.rawsthorn

Alice's in-depth, week-long Instagram posts remind me more of blog posts of the past. So slow your roll and read her insightful art/design historical take on things.

sightunseen

If you want to know what is hip, hot, and "right now" in products and interiors, this should be your first stop.

kennyschachter

Go here not for his terrible photos but for his hilarious, smart, and biting take on the world of contemporary art dealing.

Angelo Testa, Tuffet, USA, c. 1965

Amazing Free-to-Cheap (Once You're There) Design Experiences

- *Earth Room* by **Walter De Maria, New York City**: I'm not going to tell you anything about this, as it would ruin the surprise/experience. Trust me, it's so cool.
- *Broken Kilometer* by **Walter De Maria, New York City:** A subtle, introspective, yet kind of shocking permanent installation in what would be prime SoHo retail space, which makes the experience even richer for some reason. Go the same day you see Earth Room, it's just a few blocks away.
- **The North Face store, New York City**: For the monumental Harry Bertoia sculpture made for the original inhabitant, Chase Manhattan Bank. It's also a Gordon Bunshaft-designed building. A weird experience, but worth it.
- **Marfa, Texas**: The Donald Judd mecca and literally one of the most amazing places for art and design on this earth. If you haven't been, GO!
- **Indianapolis Museum of Art**: For postmodern and Memphis design. I was really surprised by the depth and breadth of their collection. Impressive.
- **The Brighton Museum, England**: Has a quirky collection including pieces I had never seen before, such as Dalí's sofa for Edward James and the largest Napoleone Martinuzzi glass plant sculpture I have ever seen!
- **MoMA**: The collection of industrial design alone is worth the trip, but recent design exhibitions such as *Century of the Child: Growing by Design* have been exceptional.
- **The Wolfsonian Museum of Decorative and Propaganda Arts, Miami:** Another unique and extremely focused museum by the legendary and obsessive collector Micky Wolfson.
- **The Brooklyn Museum**: For its design and huge open storage.

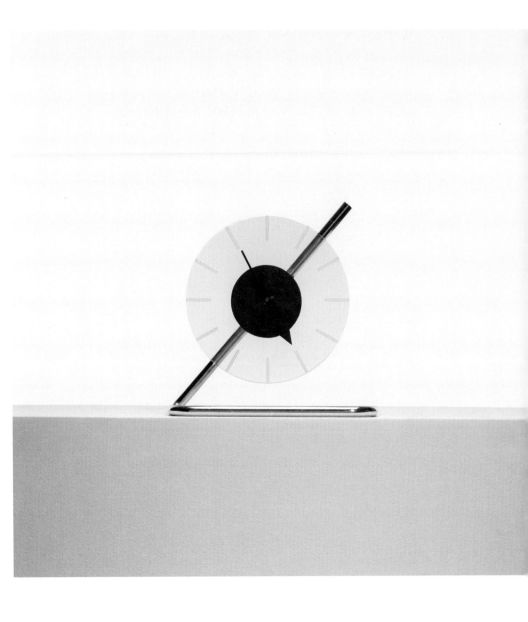

Gilbert Rohde, Z-clock, Model 4090, Herman Miller, USA, c. 1933

- **Storm King, New Windsor, New York**: One of my favorite places on earth. Five hundred acres of woods and rolling hills with 100 perfectly placed monumental sculptures by the world's greats.
- *Lightning Field* **by Walter De Maria, New Mexico** and *Spiral Jetty* **by Robert Smithson, Great Salt Lake, Utah**: Two of the great pieces of land art.
- **Opus 40, Saugerties, New York:** Another sculpture park in upstate NY, this place is so amazing, and to think it was constructed by one man is mind-boggling.
- **Gibbs Farm, Kaipara Harbour, New Zealand** This reclusive billionaire's trove of sculptures is rivaled only by Storm King.
- **All national museums in Washington, D.C.** They are free and have some of the best and earliest examples of my very favorite artists, from Modigliani to Calder. The National Gallery alone has over 900 Rothkos in their collection!!

Herbert Matter, Untitled (Knoll collage), USA, c. 1948

My Favorite Movies for the Design*

- *The Man in the Gray Flannel Suit* (1956): Look for the Heifetz lamps designed for MoMA.
- *Ruthless People* (1986): Amazing postmodern and Memphis furniture, plus Danny DeVito and Bette Midler!
- *Beetlejuice* (1988): The redecoration of an upstate New York house by New Yorkers trying to escape the NYC grind is hilarious and has amazing examples of postmodern design, both by the set designer Bo Welch and the furniture designer Shiro Kuramata.
- *A Single Man* (2009): Tom Ford's debut as a director, set in an early John Lautner house.
- *Pillow Talk* (1959): Rock Hudson's amazing bachelor pad.
- *Diamonds Are Forever* (1971): Another killer pad, another John Lautner creation, the Elrod House.
- *Playtime* (1967): Jacques Tati's modernist vision of city life.
- *The Moon is Blue* (1953): Some very early modern furniture spotting in this one.
- *The Best of Everything* (1959): For scenes from the Lever House and the Seagram Building.
- *Mon Oncle* (1958): Jacques Tati's masterpiece critiquing the move to the suburbs using Modernist French furniture as the foil. A must see!
- *The Fountainhead* (1949): Frank Lloyd Wright-type architecture and furniture.
- *North by Northwest* (1959): Good auction scene and great Frank Lloyd Wright-like house for the villain.
- *Auntie Mame* (1958): Amazing design by decade as the eccentric Auntie Mame continuously redecorates her apartment.
- *La Piscine* (1968): Country house has great art and design, the poolside furniture is amazing.

*in which one man dominates.

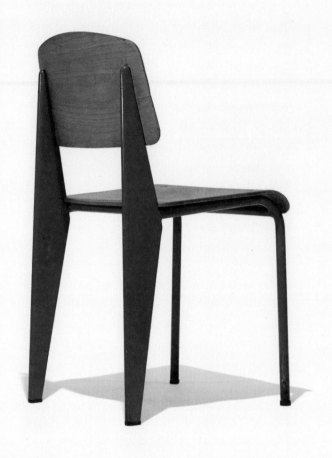

Jean Prouvé, Standard chair, No. 305, Ateliers Jean Prouvé, France, 1950

- *Le Samouraï* (**1967**): Great nightclub and Venini glass, mod furniture, and art.
- *American Psycho* (**2000**): Great for so many reasons but the art is a time capsule of the 80s: Robert Longo, Allan McCollum, Cindy Sherman, and Richard Prince all make appearances.
- *The Stranger* (**1946**): I think I'm the first person to write about this remarkable "find" of a design object in a film. In several scenes Ray Eames' iconic plywood sculpture is sitting WAY out of place in this New England cottage. How and why Orson Welles picked it is, as of yet, still a mystery.
- *Interiors* (**1978**): Woody Allen nails the "pale chic" look of 70s NYC interior design trends, ones that quickly spread and would look current again today.
- *The Damned Don't Cry* (**1950**): The last chapter of this movie was shot at Frank Sinatra's Twin Palms Estate, designed by E. Stewart Williams.
- *Blade Runner* (**1982**): For Frank Lloyd Wright's Ennis House. It's also appeared in *Female* (1933), *House on Haunted Hill* (1959), *The Day of the Locust* (1975) and last but not least, *The Karate Kid III* (1989).
- *Lethal Weapon 2* (**1989**): Don't miss John Lautner's Garcia House.
- *Body Double* (**1984**): John Lautner's amazing Chemosphere House that is presently occupied by publisher Benedikt Taschen.
- *L.A. Confidential* (**1997**): Richard Neutra's Lovell Health House featured prominently.
- *The Big Lebowski* (**1998**): It's John Lautner again (I know!) in this classic with The Sheats-Goldstein Residence taking center stage.

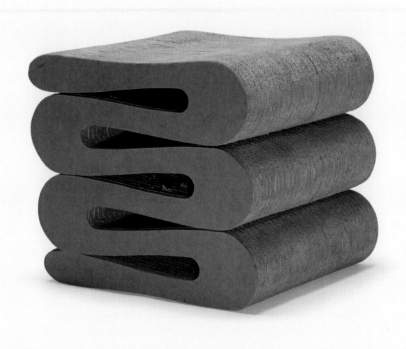

Frank Gehry, Wiggle stool, Easy Edges, Inc., Canada/USA, 1972

The Advice I Most Wish Someone Had Told Me When I First Started

Always ask to use the bathroom in a dealer's shop. There is always stuff stashed in there and you have an excuse to walk through the "back room" to get there. This doesn't really work in galleries, but in antique stores and single-owner shops it is especially effective.

At an art fair, always check out the "closet" room where smaller pieces will be displayed. It will look like you are not supposed to enter, but most of the time it is fine. Ask, if it feels like you should.

Ask, ask, ask. Unless you should keep your mouth shut...

Photograph by Scott Newman

Acknowledgements

I would like to thank Alex, Clyde, and Wes Del Val for their patience and support during this process. Big thanks to Emily Burke for her transcription skills. A HUGE thanks to Richard Wright and team at Wright in Chicago for all the images in the book; they were integral to the project and represent many things that have run through my hands and many more that I wish had! Thanks also to Clemens Kois for his amazing "stacked" cover images which he spontaneously built in the gallery from pieces in my current inventory! And I can't forget Anotheroom for providing me with the space and cold beverages I required for finishing this book.

THE HUNT
Navigating the Worlds
of Art and Design

Text © 2017 Patrick Parrish
All photographs © their respective owners and used with permission

Published in the United States by powerHouse Books,
a division of powerHouse Cultural Entertainment, Inc.
32 Adams Street, Brooklyn, NY 11201-1021
telephone: 212.604.9074
e-mail: info@powerHouseBooks.com
website: www.powerHouseBooks.com

First edition, 2017

Library of Congress Control Number: 2017960690

ISBN 978-1-57687-851-4

Printing and binding through Asia Pacific Offset

Book design by Krzysztof Poluchowicz
Cover photographs by Clemens Kois

10 9 8 7 6 5 4 3 2 1

Printed and bound in China

3 1170 01056 7927